Young Jackie

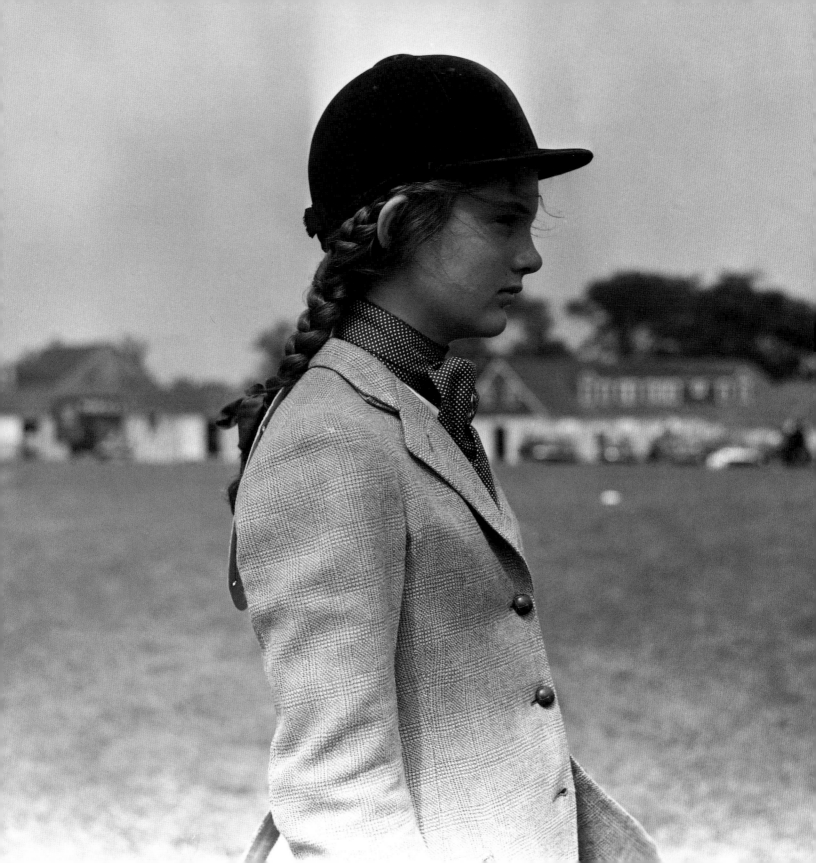

Young Jackie

PHOTOGRAPHS OF JACQUELINE BOUVIER

Photography by
Bert Morgan

Introduction and Chronology by
Olivia Harrison

VIKING STUDIO

VIKING STUDIO
Published by the Penguin Group
Penguin Putnam Inc., 375 Hudson Street, New York, New York 10014, U.S.A.
Penguin Books Ltd, 80 Strand, London WC2R 0RL, England
Penguin Books Australia Ltd, 250 Camberwell Road, Camberwell, Victoria 3124, Australia
Penguin Books Canada Ltd, 10 Alcorn Avenue, Toronto, Ontario, Canada M4V 3B2
Penguin Books India (P) Ltd, 11 Community Centre, Panchsheel Park, New Delhi, 110 017, India
Penguin Books (N.Z.) Ltd, Cnr Rosedale and Airborne Roads, Albany, Auckland, New Zealand
Penguin Books (South Africa) (Pty) Ltd, 24 Sturdee Avenue, Rosebank, Johannesburg 2196, South Africa

Penguin Books Ltd, Registered Offices:
Harmondsworth, Middlesex, England

First published in 2002 by Viking Studio,
a member of Penguin Putnam Inc.

1 3 5 7 9 10 8 6 4 2

Photographs copyright © Getty Images, 2002
Introduction and chronology copyright © Olivia Harrison, 2002
All rights reserved

LIBRARY OF CONGRESS CATALOGING-IN-PUBLICATION DATA
Morgan, Bert, 1904–1986.
Young Jackie : photographs of Jackie Bouvier / by Bert Morgan ;
introduction and chronology by Olivia Harrison.
p. cm.
ISBN 0-670-03082-1
1. Onassis, Jacqueline Kennedy, 1929–Childhood and youth—Pictorial works.
2. Celebrities—United States—Pictorial works.
3. Presidents' spouses—United States—Pictorial works. I. Title
CT275.O552 M67 2002
973.922'092—dc21
[B] 2001043774

This book is printed on acid-free paper. ∞

Printed in Japan
Designed by Jaye Zimet
Editor: Christopher Sweet
Book concept by Eric Rachlis

FRONTISPIECE: *Jackie, age 12, at the East Hampton Horse Show, August 23, 1941.*
RIGHT: *Jackie with her father, John V. Bouvier III, East Hampton, July 23, 1947.*

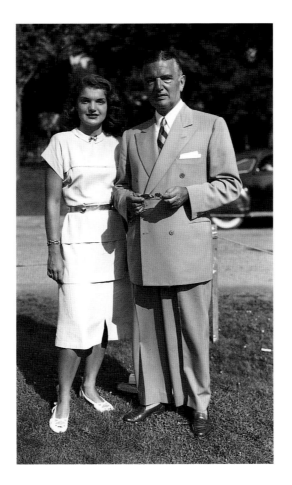

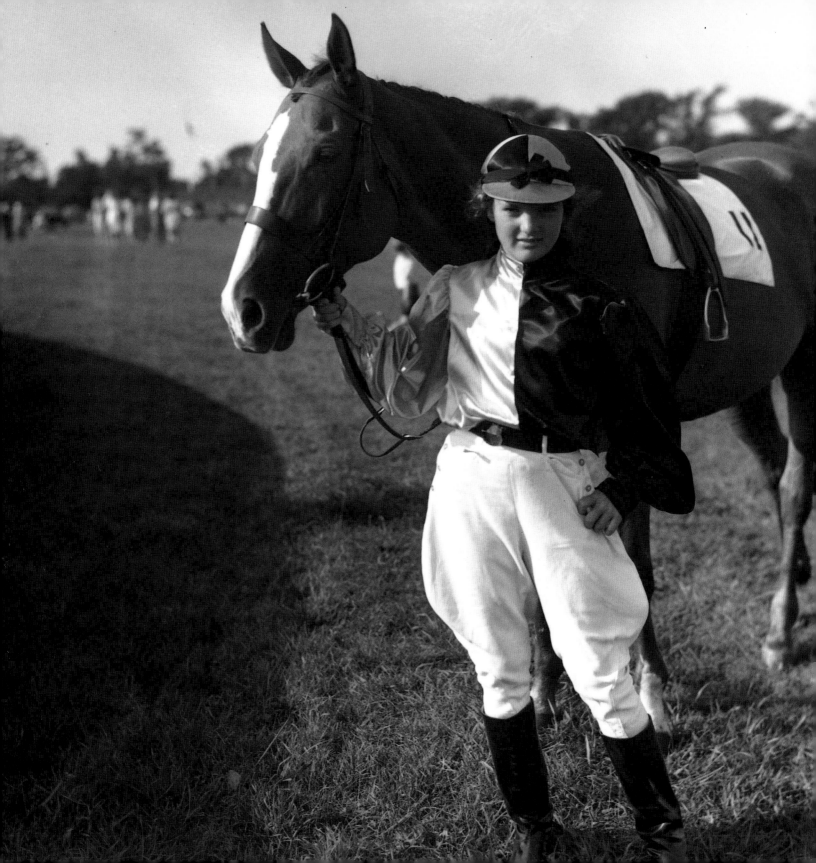

INTRODUCTION

Jacqueline Bouvier Kennedy Onassis is forever etched in the public memory. Now frozen in time by countless photographs, her wide-set big brown eyes and deep, intense gaze both reveal and withhold who she was. The myriad photographs of Jackie provide tantalizing glimpses into the remarkable woman who, though both universally known and essentially mysterious, would be heard to say "I've always been the same person." Indeed, in childhood, adolescence and adulthood alike, her steadfast expression stays true to the image of strength, intelligence, beauty and class that she still embodies today. Pictures of her as a little girl show the same resolute look, the strength of character, the confident grace, the feminine allure she exuded throughout her life as well as, in certain circumstances, the unreserved, candid smile she would occasionally—brilliantly—offer to the world.

As a woman, Jackie mesmerized the world with her glamour and

Jackie with her horse Danseuse, August 1942.

earned unending admiration for her loyalty and courage. Her story begins in a privileged world, surrounded by a loving family, growing up in circumstances that would provide her the opportunities to rise to an exceptional sort of stardom. The photographs collected here show Jackie as a young girl, as yet untouched by myth or media yet already in the public eye. Society photographer Bert Morgan, unaware of Jackie's future fame, recorded her early public appearances at East Hampton dog shows, horse competitions, weddings and other social events. In these pages, we can already see the beauty, self-possession and poise that would later define Jackie as an icon of twentieth-century America.

Jackie was born July 28, 1929, on a hot summer's day in Southampton, six weeks after her due date. Her father, John Vernou Bouvier III, nicknamed Black Jack for his Hollywood good looks and philandering habits, was a wealthy stockbroker of French Catholic descent, and her mother, Janet Lee, was a much younger Irish Catholic, also very rich but keen to improve on her family fortune. The Lee and Bouvier families both lived in New

York City and owned property in East Hampton, where they spent their summers. Lasata ("place of peace" in a Native American dialect), the fourteen-acre Bouvier estate, housed the Bouvier clan every summer and proved to be a crucial part of Jackie's life. There she learned to ride horses, took to swimming and developed her lifelong love of nature. Horses were to play an especially important role in Jackie's happiness, and all her life she would rely on them for solace and support—just as her mother did in order to cope with her husband's infidelities. It was Janet who gave Jackie her passion for horses—and taught her that a woman could succeed only by marrying for money, albeit at the cost of much pain and suffering.

Jackie was raised in the elite social circles of New York and the Hamptons, where money and prestige determined success, and where a family's chief concern was upholding the family name. Both the Lees and Bouviers were obsessed with social position. Though both families descended from poor working-class immigrants (the Lees had fled the Irish potato famine and the first Bouvier was a cabinetmaker), they had separately invented dignified family trees to justify their positions in soci-

ety. While the Lees claimed to be related to the Lees of Virginia, John Vernou Bouvier, Jr., invented a lineage tracing his ancestry back to French aristocracy—according to him the Vernous had been of noble blood since the eleventh century and the Bouviers since the seventeenth. Jackie was raised believing that she was different from most Americans and deserved to be treated accordingly. Indeed, the family predilection for myths of aristocratic origins and self-made grandeur would manifest itself during her White House years and in the aftermath of her husband's assassination with the construction of the Camelot myth.

As soon as Jackie was born, the Bouviers took pains to assert her social standing and made sure their daughter would be in the forefront of high society attention. By the age of two Jackie had already been mentioned in the social columns for her East Hampton birthday party and her appearance at a dog show that day with her beloved Scottie dog Hootchie. She attended the most reputable girls' schools on the East Coast: the Chapin School for Girls in New York City, Holton Arms in Georgetown, and Miss Porter's, a boarding school in Connecticut. Her parents, who

took pride in their Catholic heritage though they were not particularly religious, wanted Jackie to go to schools attended mostly by girls of the Protestant upper class, where she would be introduced into WASP high society. When Jackie came of age, Janet organized debutante balls for her daughter, who was voted "Debutante of the Year" in her first year at Vassar College. She made several trips to Europe in her early twenties and spent her junior year in Paris, perfecting her knowledge of the culture and sophistication in the land of her forebears. Jackie was no ordinary young girl. She was endowed with all the tools—money, beauty, intelligence, social standing, education and culture—needed to secure and to improve her social standing, which in those days meant marrying well.

In all these images of Jackie as a young girl, we find the same self-assured, mature, regal expression. Jackie had a very strong sense of who she was. Her father absolutely adored her and constantly reminded her how beautiful and talented she was. Her grandfather Bouvier was also extremely proud of her and admired her artistic and intellectual capacities, which he felt he had helped her develop. In fact, the whole family was slightly in

awe of Jackie. Their unfailing support combined with her personal success gave her the confidence to achieve her every goal. Jackie believed in herself—the expression we see in these pictures, the determined gaze she directs at the camera, reveal her confidence and ambition. What she wanted, she sought and obtained. Her cousins gladly ran around fetching things for her, and her beloved Grampy Jack barely protested when she asked to have her favorite horse, Danseuse, sent up to her school at an extravagant cost. She learned the skill of persuasion both from her domineering mother, who instructed her in the way of economic success, and from her philandering father, who taught her the art of seduction and the power of charm.

Only her mother refused to give in totally to Jackie. Janet was not an affectionate woman. She envied the loving relationships her daughter had with Black Jack and the Bouviers, and strongly tempered their praise and love with criticism and occasional bursts of irrational anger. Jackie's insecurities undoubtedly stemmed from this lack of maternal love. And though she was certainly a fortunate little girl raised in a privileged envi-

Jacqueline Bouvier, age 6, with her mother, Janet Lee Bouvier, at the Smithtown Horse Show, St. James, Long Island, September 1935. They were entered in the parent-child class.

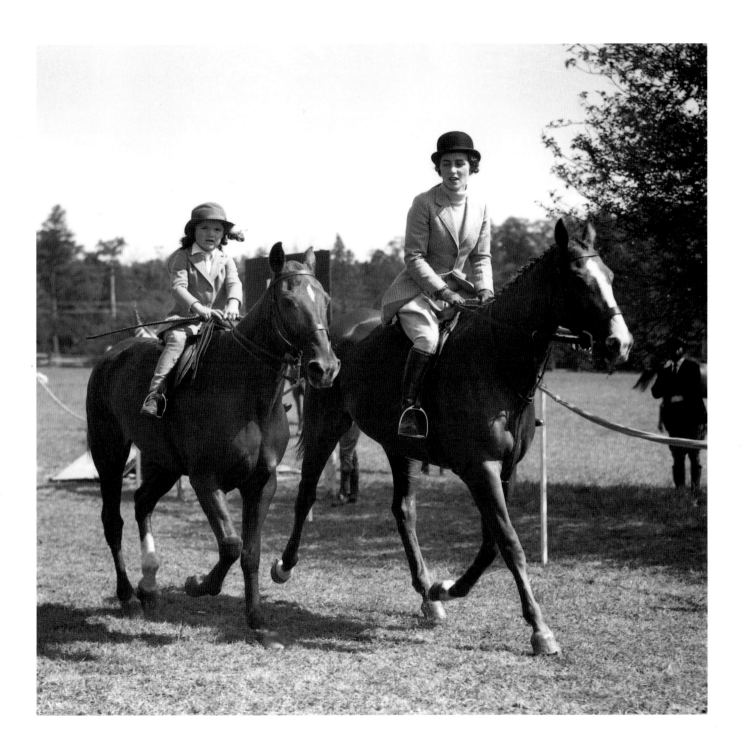

ronment, Jackie's childhood was far from idyllic. Her parents fought constantly. Black Jack was an incurable womanizer and in no way meant for marriage; Janet's pride and quick temper made it impossible for her to ignore his chronic infidelities. The situation worsened as time went by. Janet found reasons to quarrel with Jack's drinking habits, his love of gambling and his tendency to spend whatever money he made. She had married what she thought was a rich man, only to realize that wealth came and went in his volatile hands. Money was a constant preoccupation in Jackie's family, and Janet passed on to Jackie her fear of financial insecurity. The only way for women to have anything was through men, and Jackie would depend on their good fortune for most of her life.

Her parents' quarrels affected Jackie. In the face of the cold, painful reality of parental strife, she withdrew into herself, seeking peace and comfort in her imagination and little girl thoughts. Her cousins and friends remember her as a reserved, serious child who preferred solitary pursuits to group activities. She would tuck herself in a corner to read, write or draw, and she also loved to ride or swim, lost deep in her own world. And

although this reserve did not stop Jackie from forming friendships or enjoying a normal social life as she blossomed into a young woman, she would always protect her privacy and need for solitude—even at the height of her fame.

In these pictures, Jackie is self-aware, intense, independent—in a class apart. The image of nine-year-old Jackie sitting proudly on her cherished Danseuse, in jodhpurs, tweed jacket and braids, captures the striking poise, magnetic personality and compelling beauty that would later beguile the world. There is something prescient in this little girl's composure and dignity. Indeed, the aura of nobility she exuded as a child turned out in her case to be justified.

Leading her pony, Buddy, at the Southampton Riding and Hunt Club for the annual horse show, Long Island, New York, August 1934.

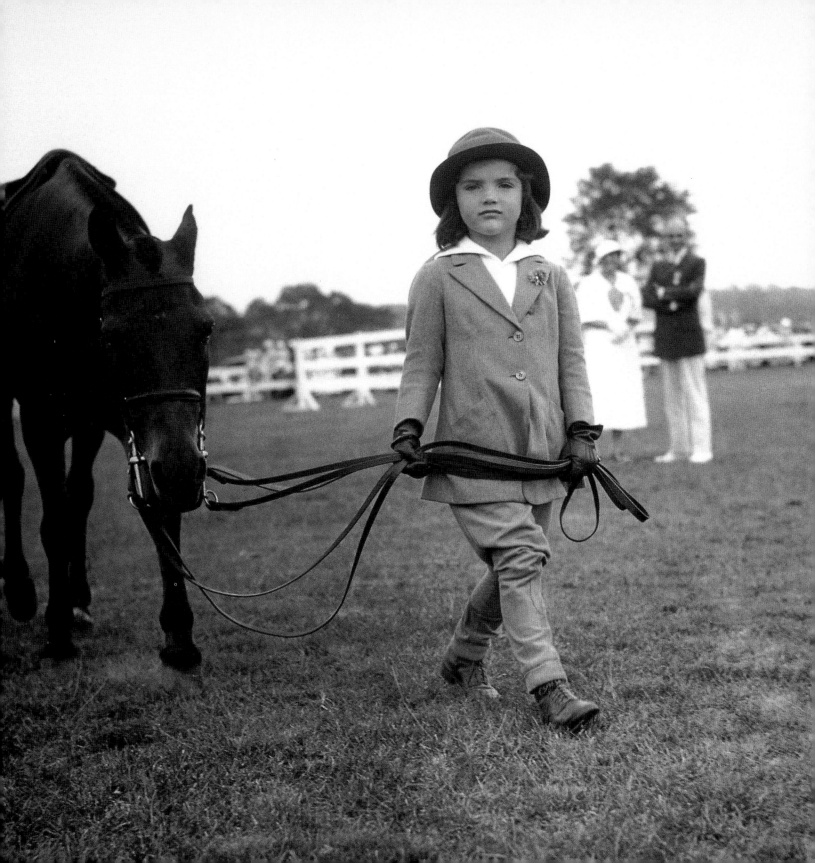

Jackie on horseback while her father holds the reins in
lead-line class at the Smithtown Horse Show, August 1933.

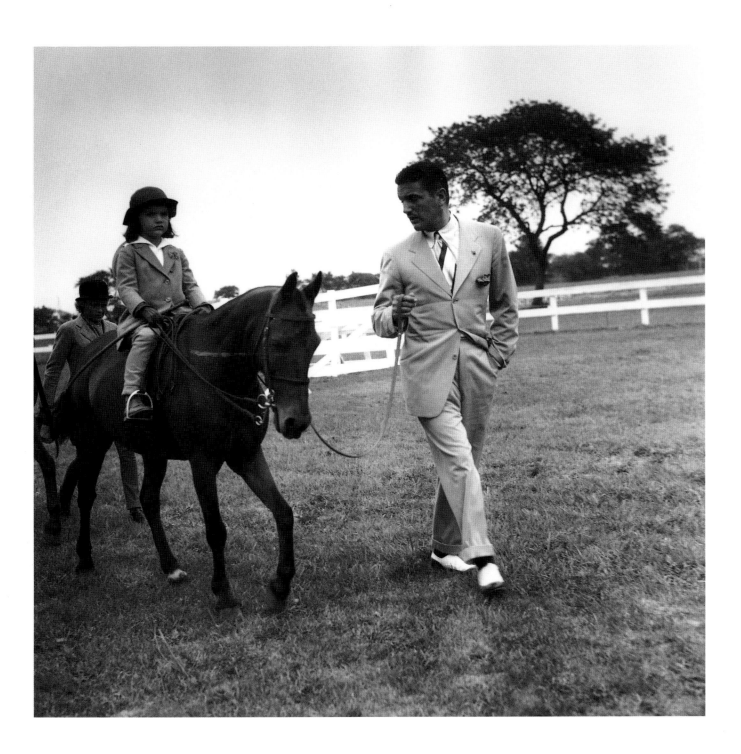

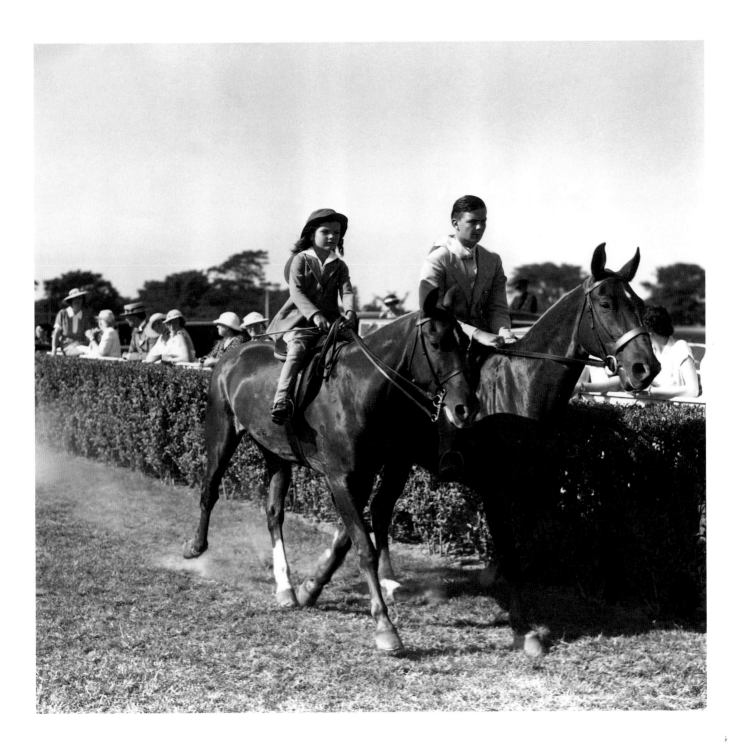

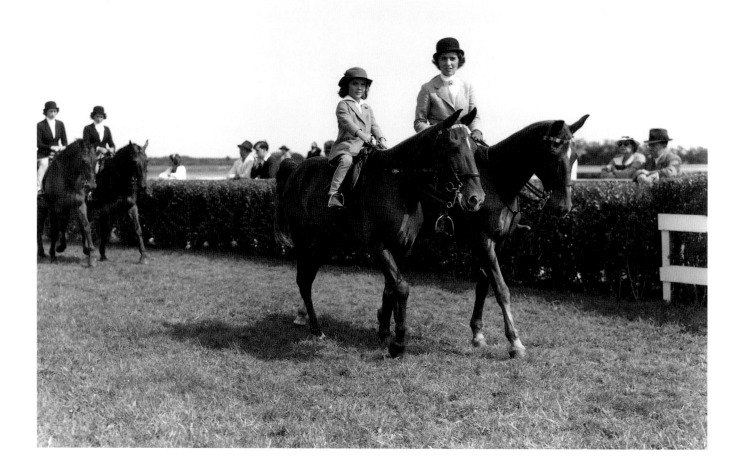

Janet Lee Bouvier and her daughter, East Hampton, July 26, 1933.
RIGHT: *Mother and daughter at the Smithtown Horse Show,*
entered in the parent-child class, September 1933.

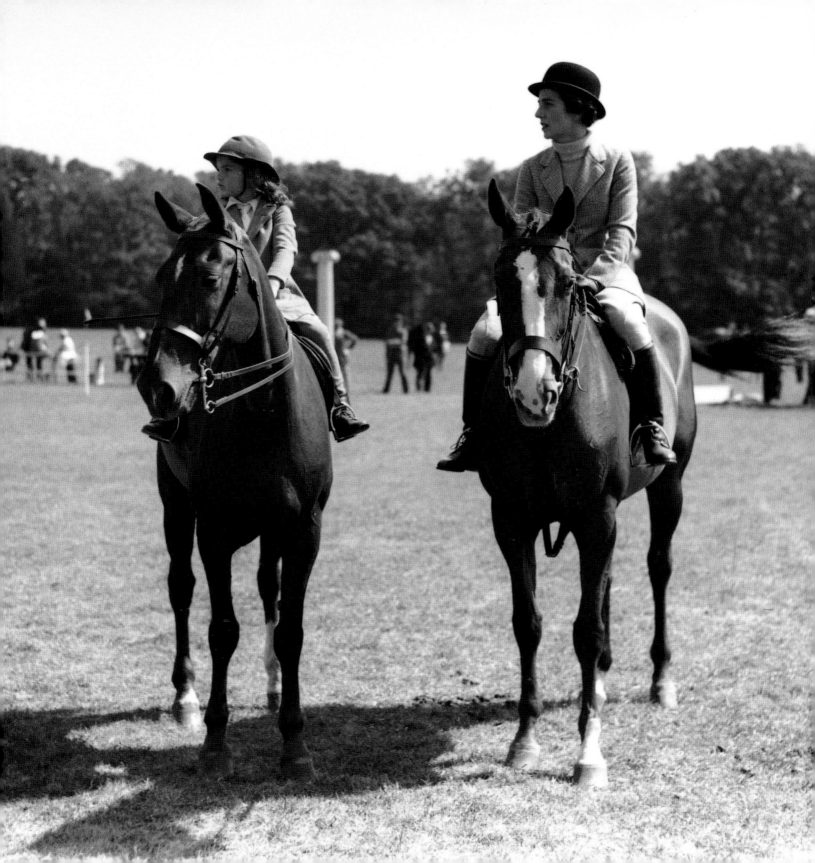

Jackie with her Great Dane, King Phar, at the thirty-fifth annual dog show at the Long Island Kennel Club, Seawane Club, Hewlett Harbor, New York, 1935.
OVERLEAF: *Jackie with her mother and her dog, Bonnet, at a local fair in East Hampton, July 1935.*

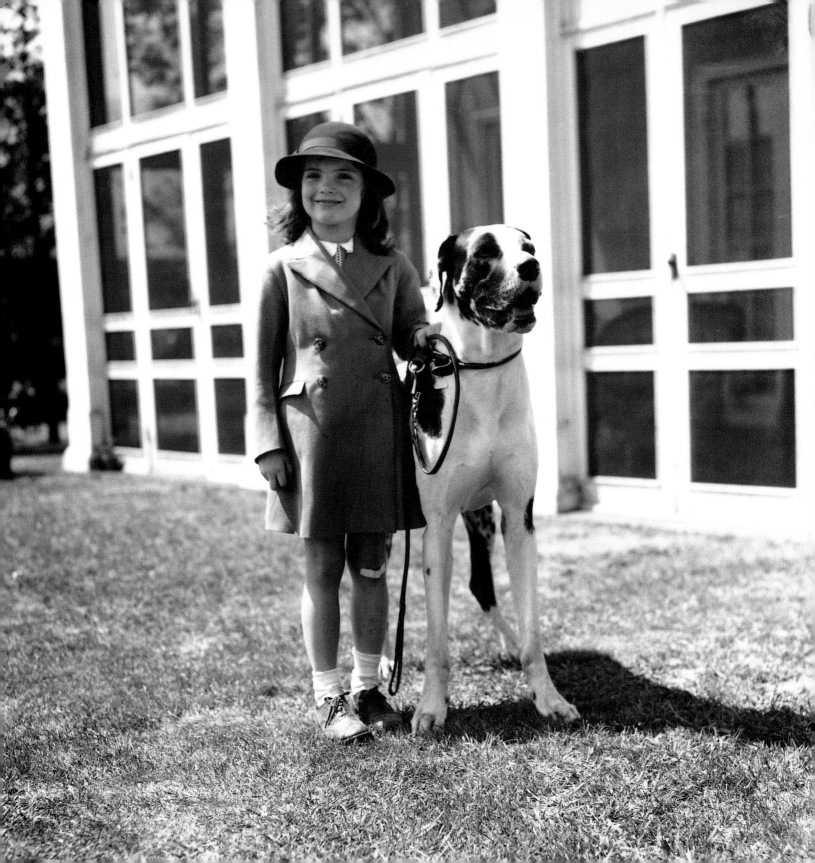

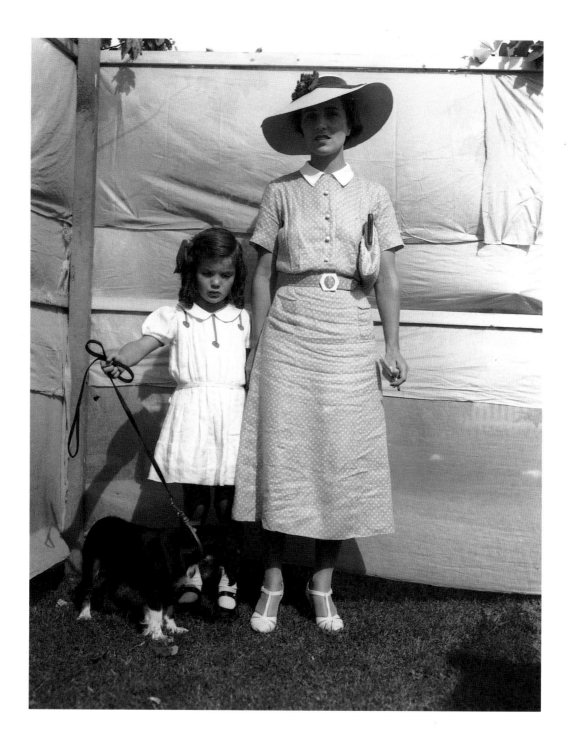

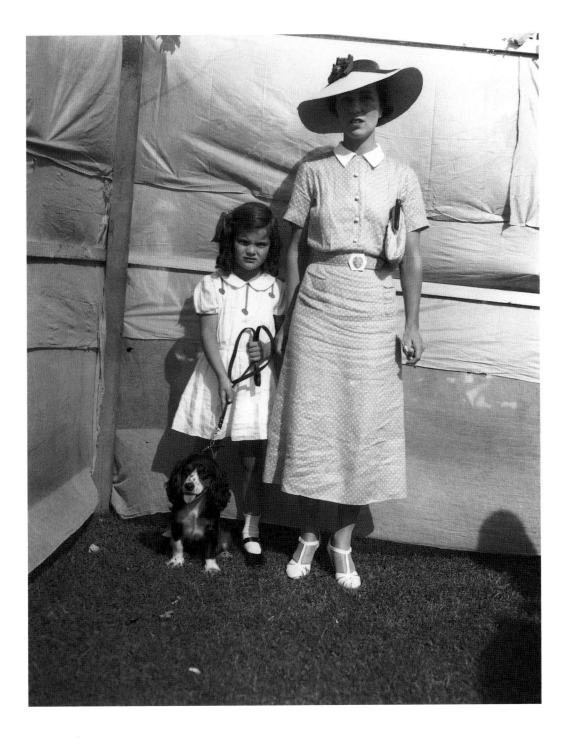

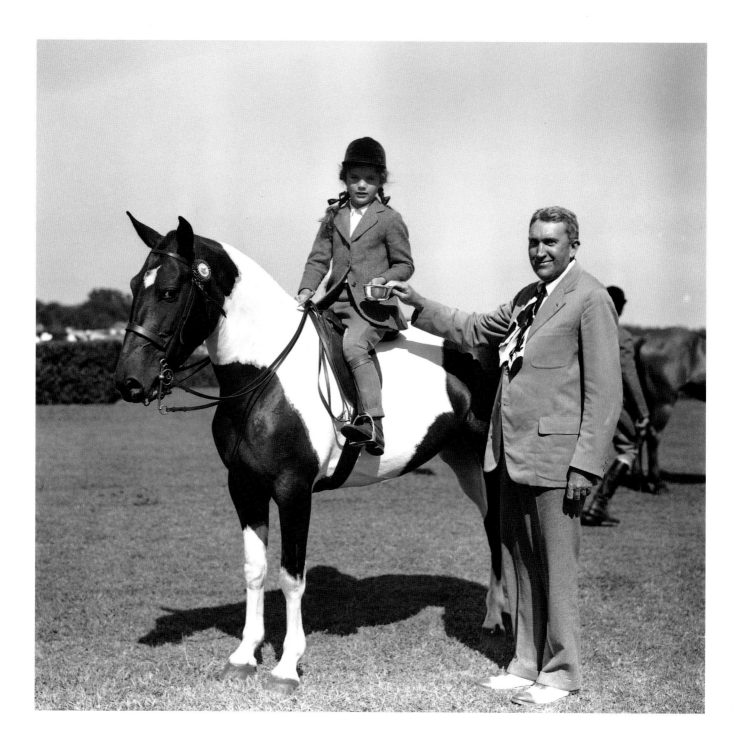

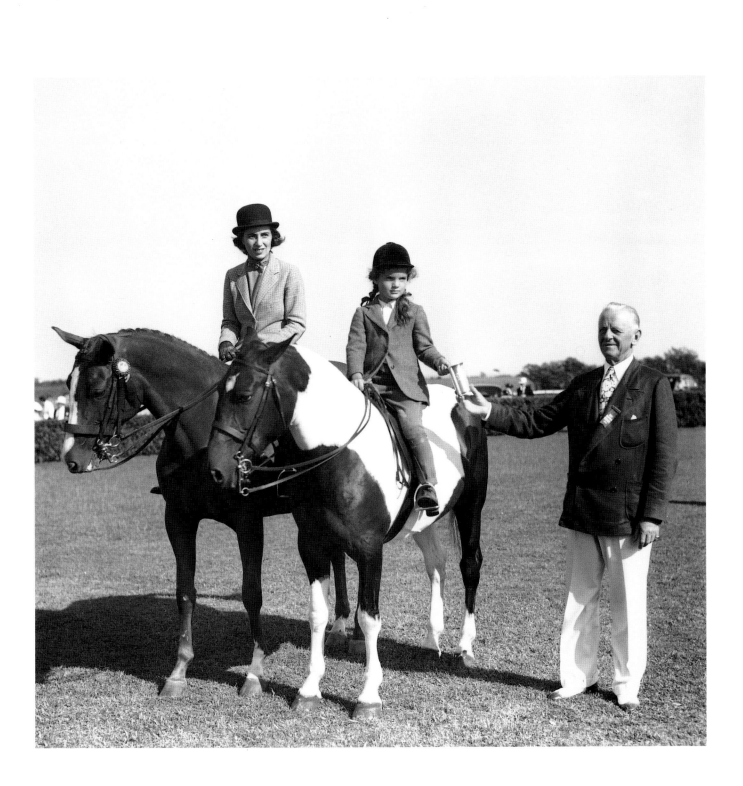

PREVIOUS PAGES: *Dr. George Roberts presenting the trophy to Jacqueline Bouvier for children under nine years of age. Jackie is on her piebald pony Dance Step; mother and daughter receiving the Family Class trophy, presented by Albert Pardridge, at the East Hampton Horse Show, August 14, 1937.*
RIGHT: *Janet and Jackie and horse Stepaside at the East Hampton Horse Show, August 14, 1937.*
OVERLEAF: *Jackie at the Smithtown Horse show at St. James, Long Island, August 28, 1937.*

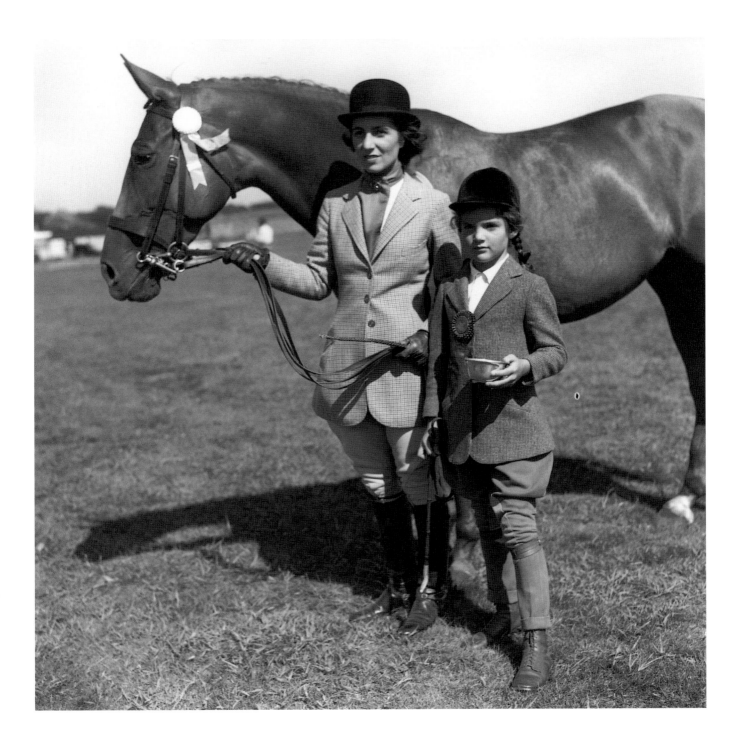

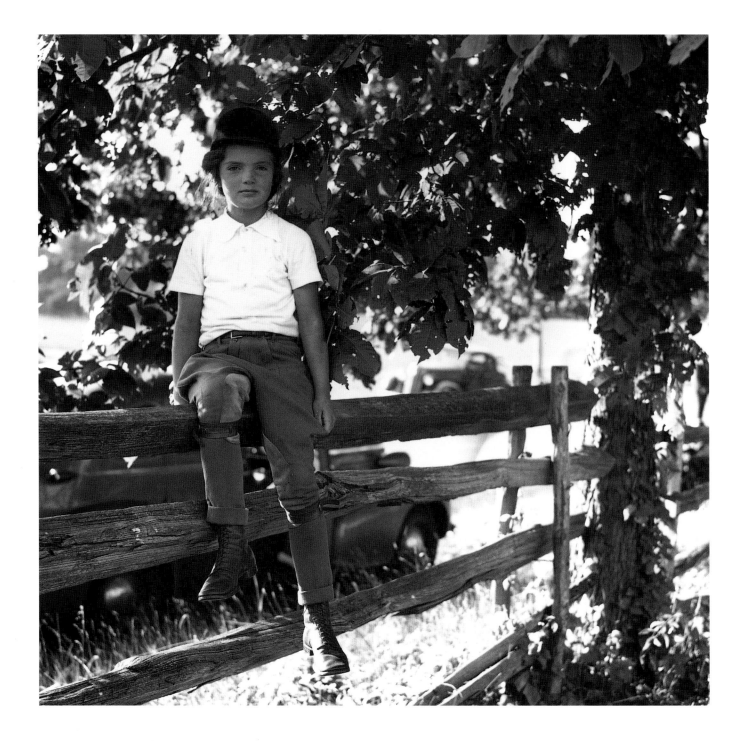

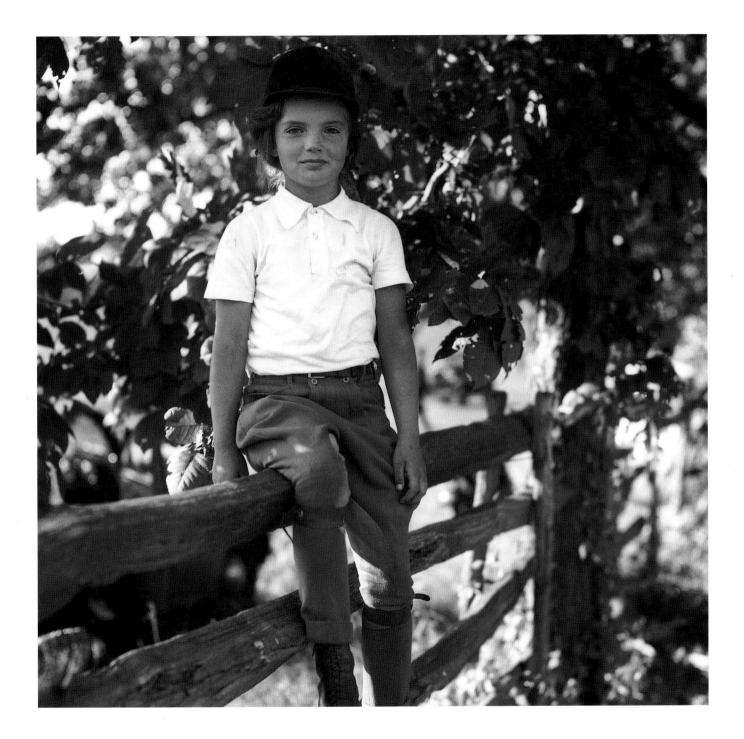

Jackie with her dog Tammy, South Hampton, July 4, 1938.
OVERLEAF, LEFT: *Jackie on Danseuse. To the right are*
Murray McDonnell, Richard Newton, Randall E. Poindexter
and A.T. Gorduier, Jr., Smithtown, July 4, 1938.
OVERLEAF, RIGHT: *Jackie on Danseuse,*
with Richard Newton, Smithtown, July 4, 1938.

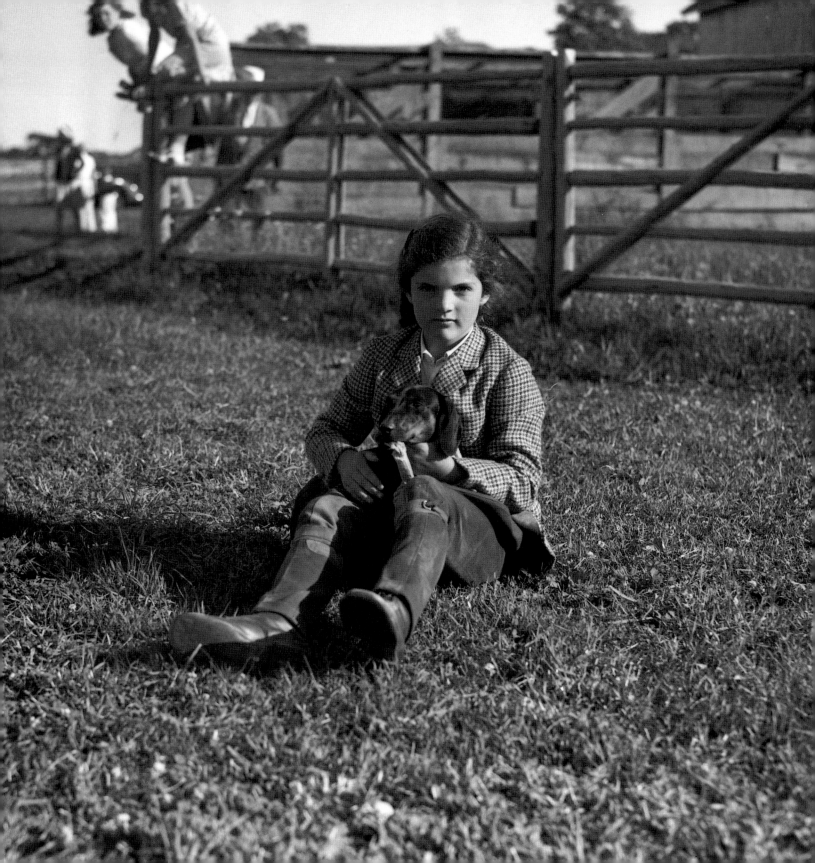

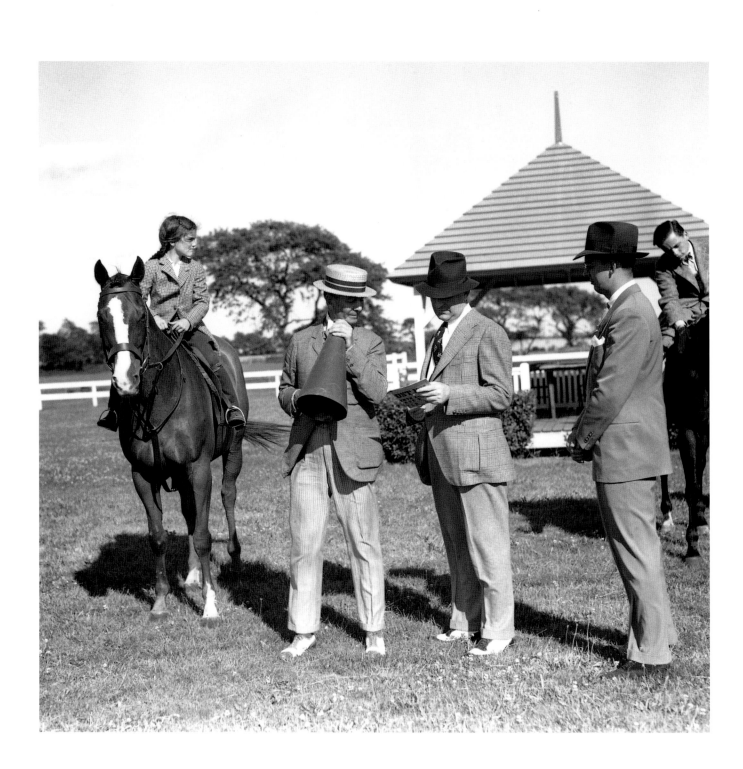

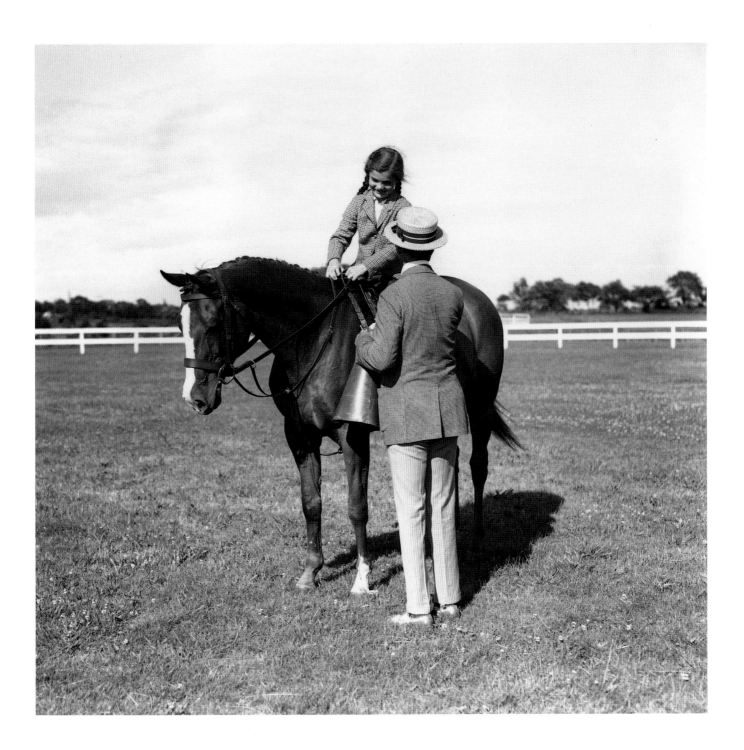

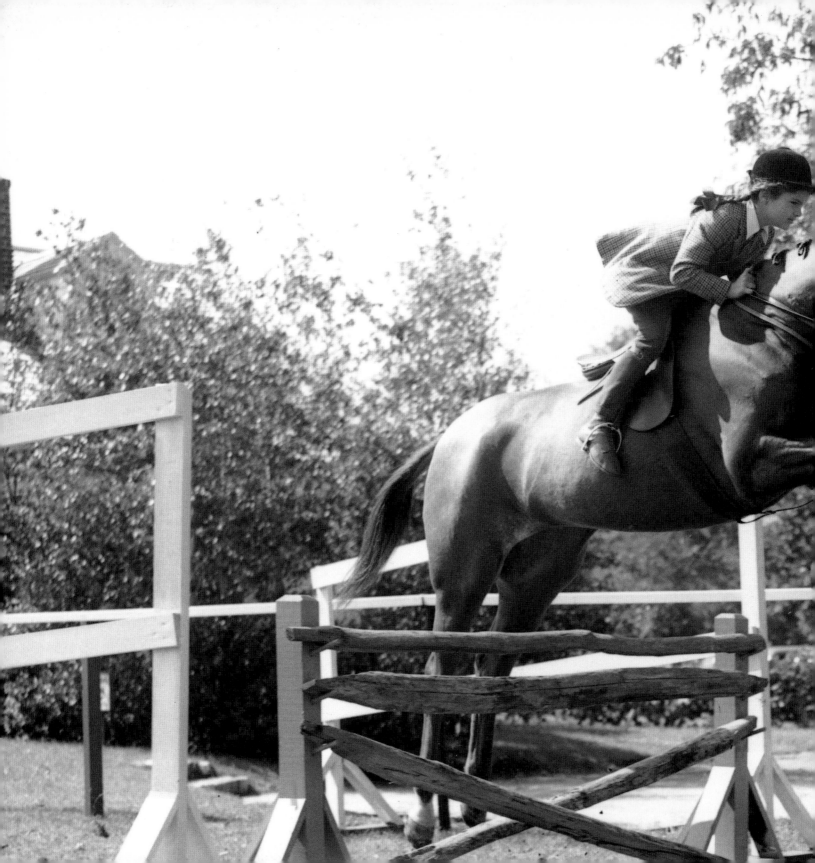

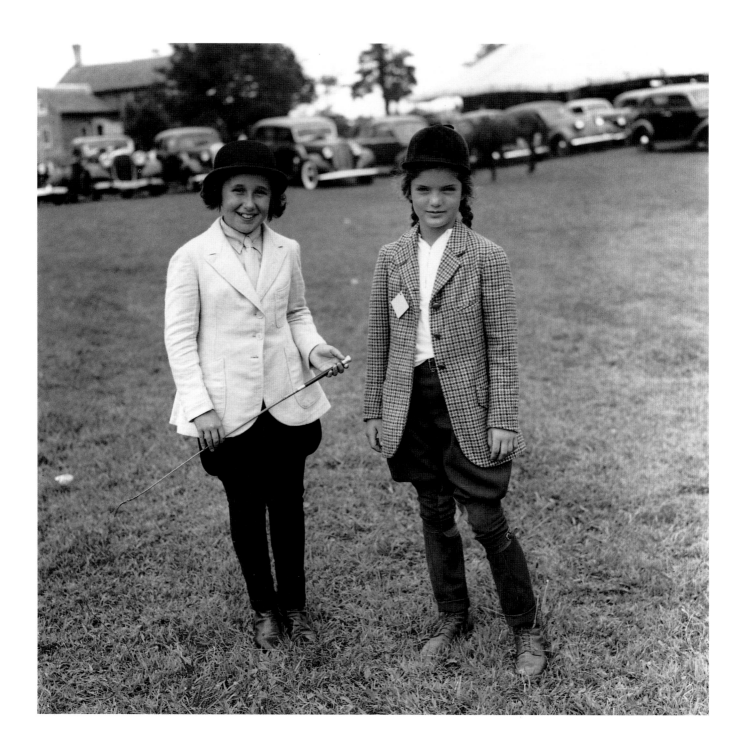

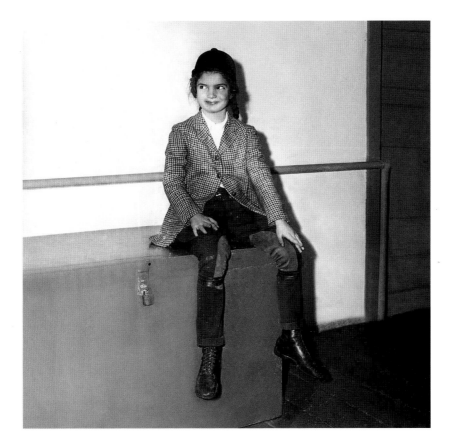

Jackie at the Boulder Brook Horse Show,
Scarsdale, New York, December 3, 1938.
LEFT: *Jacqueline Bouvier with Jane Renwick St.*
John at the Southampton Horse Show, August 6, 1938.
PREVIOUS SPREAD: *Jackie on Danseuse taking a jump, Piping*
Rock Horse Show, Locust Valley, New York, October 1, 1938.

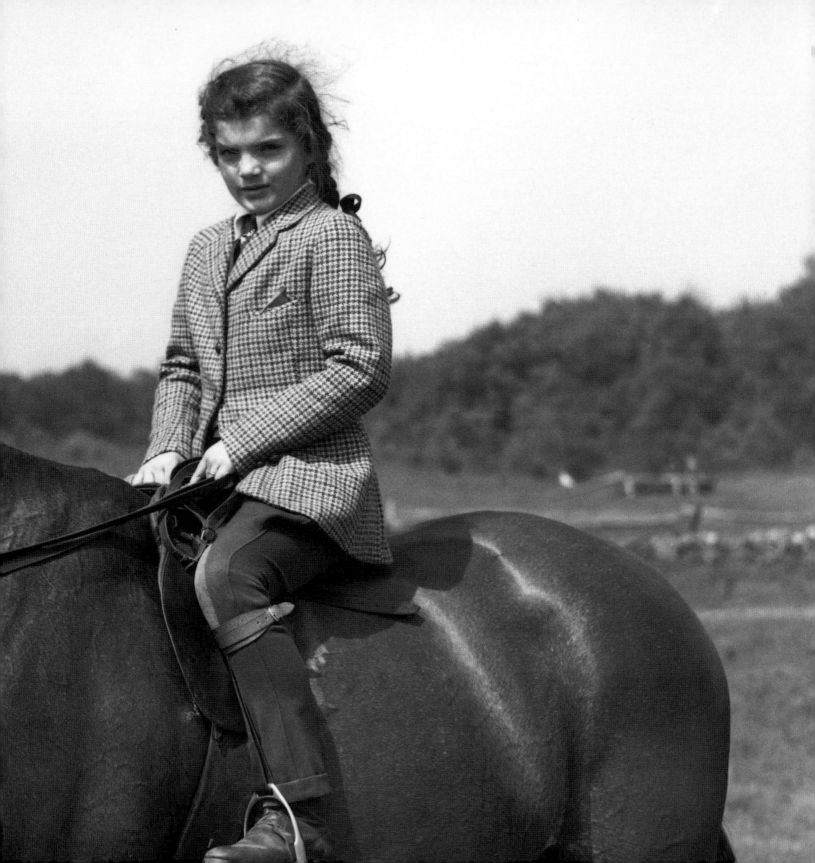

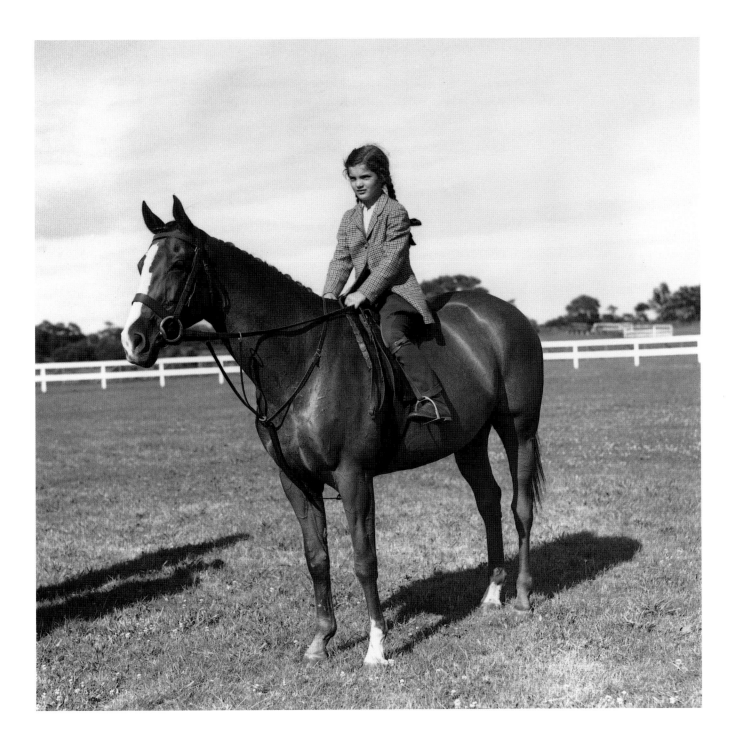

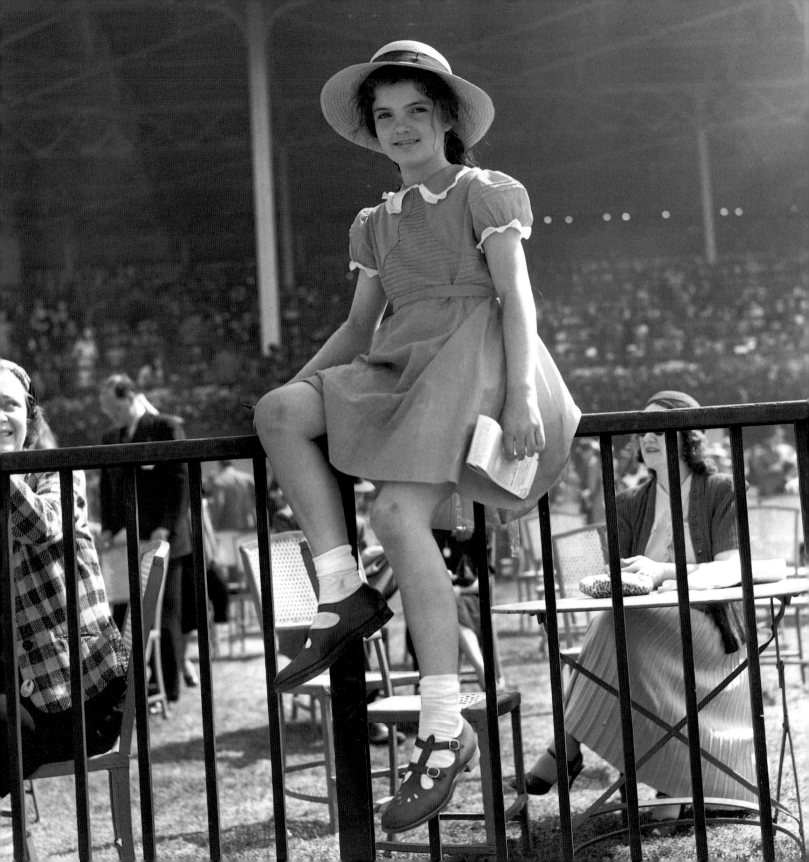

Jacqueline Bouvier, at the Turf and Field Club,
Belmont Park, New York, May 30, 1939.
OVERLEAF: *Left to right, Jackie, Mrs. Allan McLane,*
Jr., and Jackie's mother, Mrs. John V. Bouvier III, in the
stands at the Tuxedo Horse Show, New York, June 3, 1939.

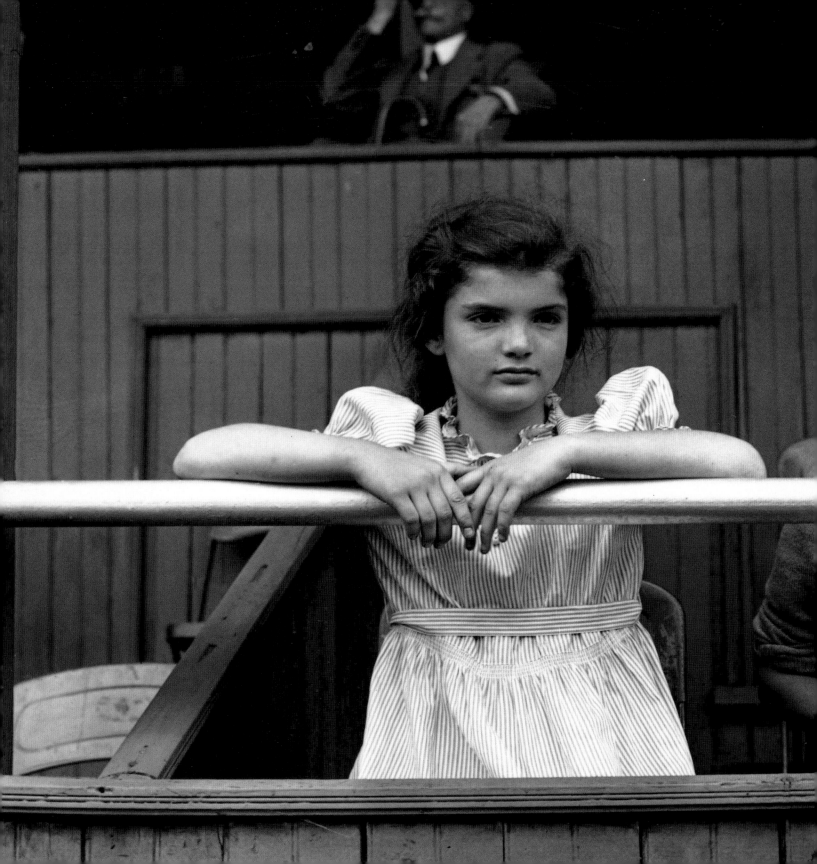

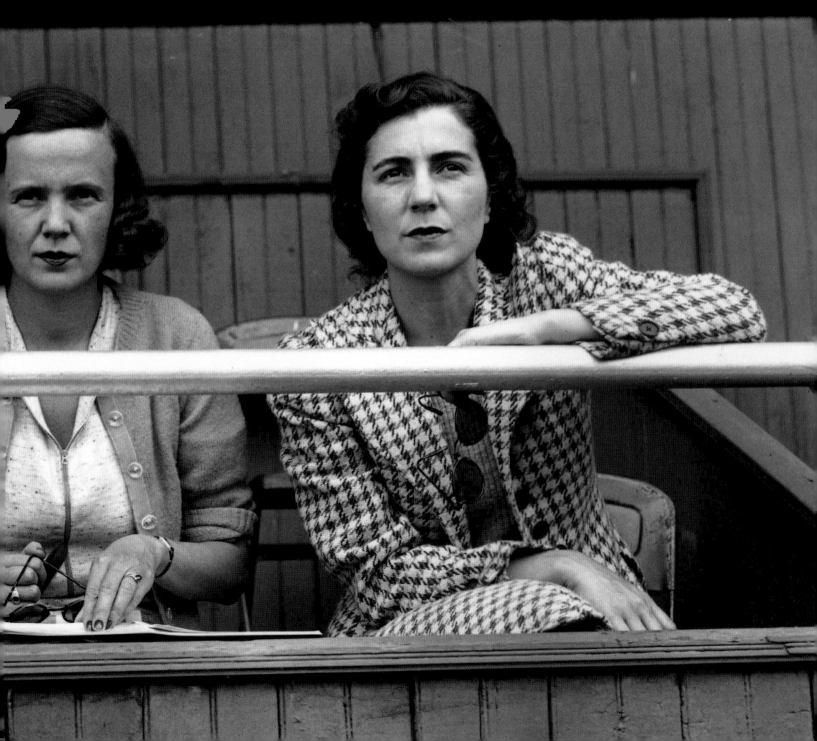

Jackie on horseback after winning the balloon-breaking
contest at the Southampton Gym, July 1939.

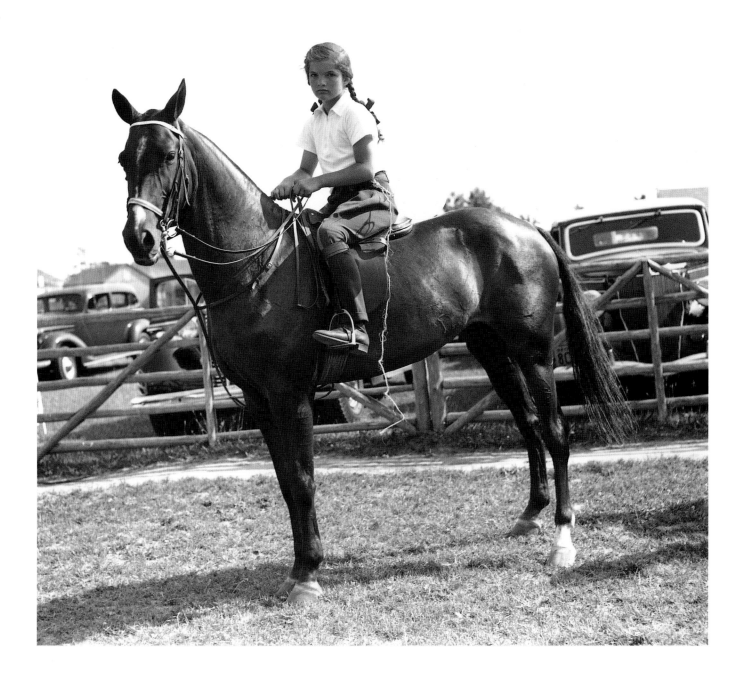

Jackie during the jumping class at the Southampton Horse Show
held at the Riding and Hunt Club, South Hampton, July 29, 1939.

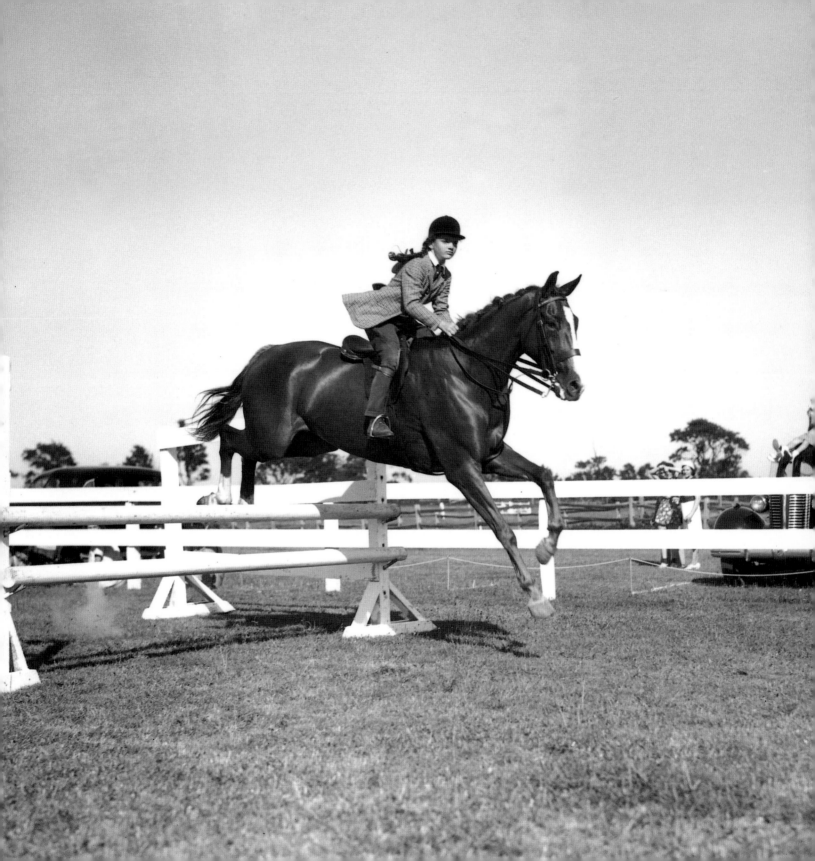

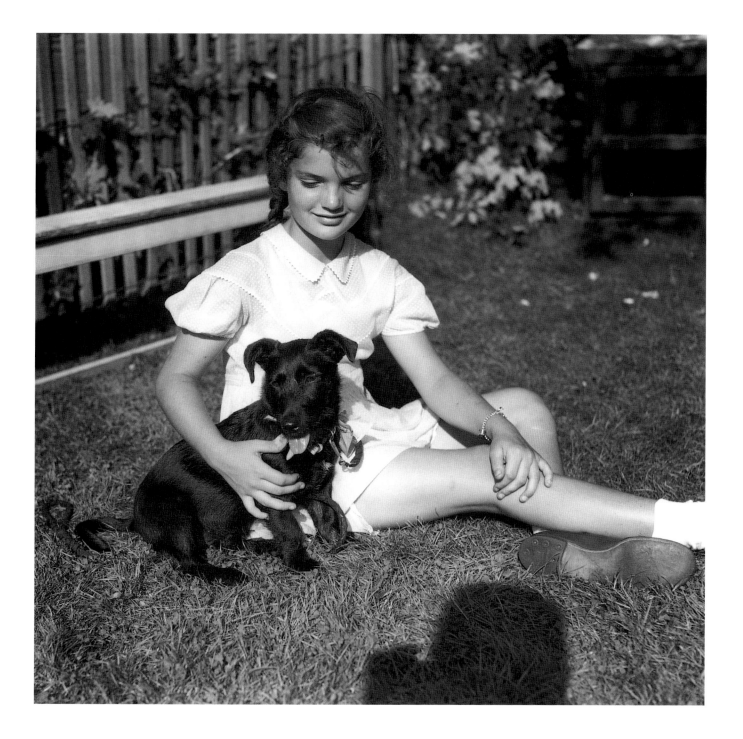

Jackie and her dog Tammy at a dog show
at the East Hampton Fair, July 28, 1939.

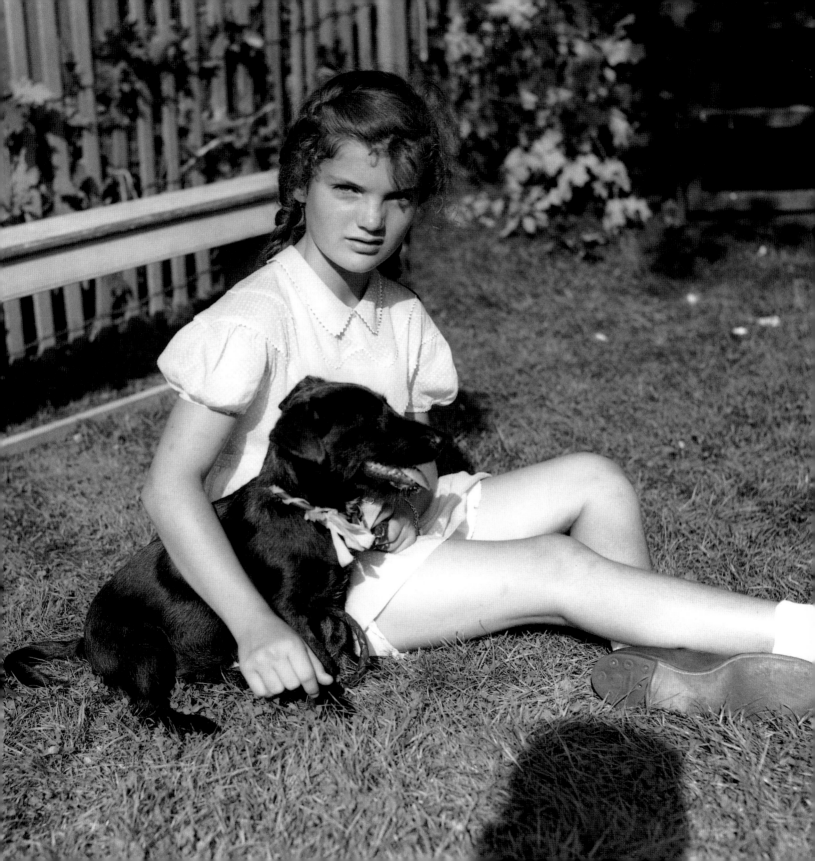

*Jackie in costume as an Indian girl with her piebald pony,
Dance Step, East Hampton Horse Show held at the
East Hampton Riding Club, August 12, 1939.*

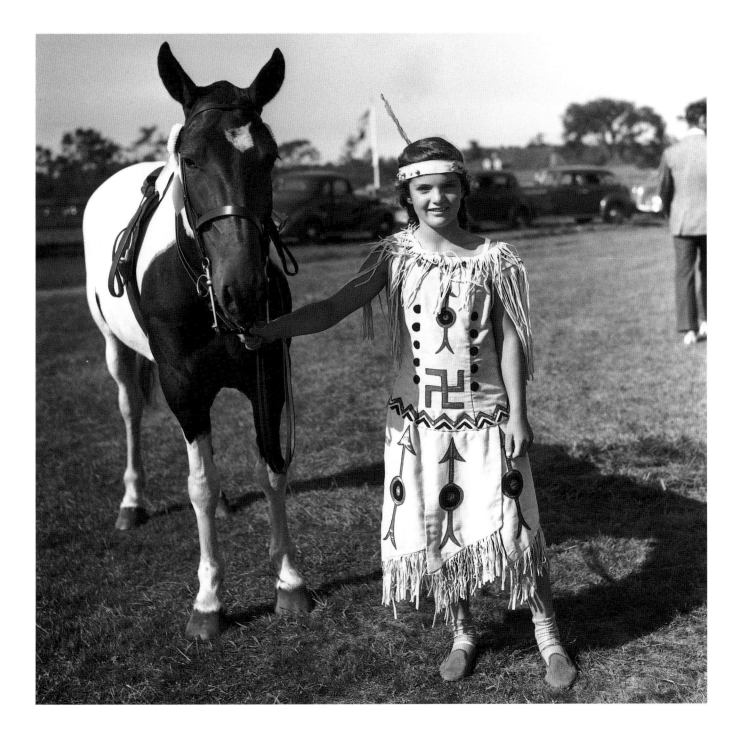

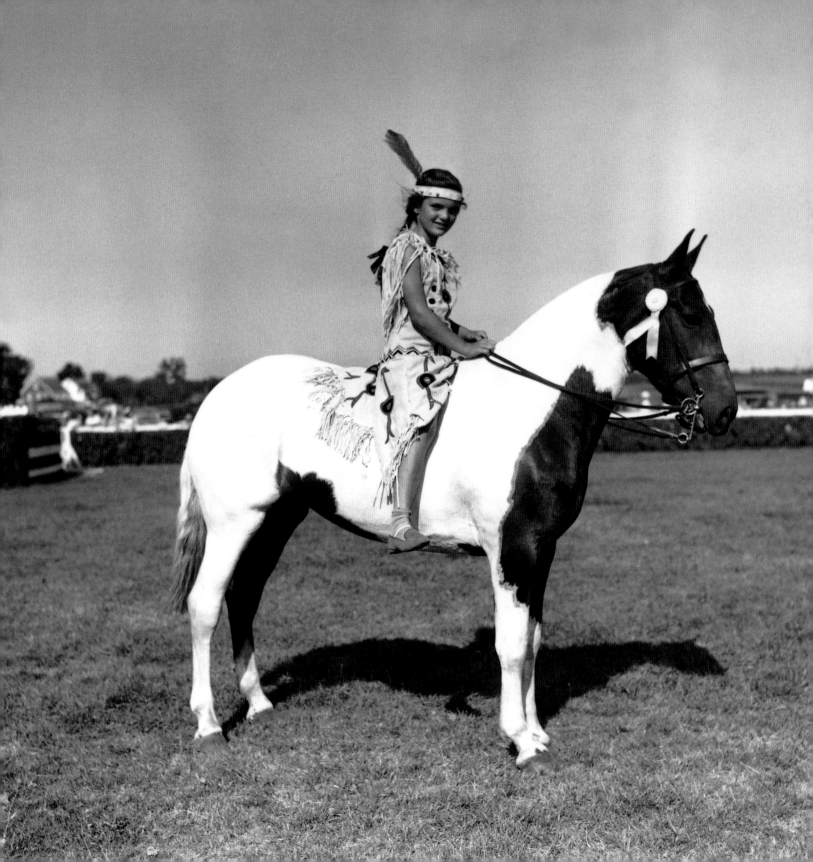

Jackie won a prize in the costume class at the
East Hampton Horse Show, August 12, 1939.

*Frances Gardiner, Jay Spalding and Jackie, in
costume at the East Hampton Horse Show, August 12, 1939*

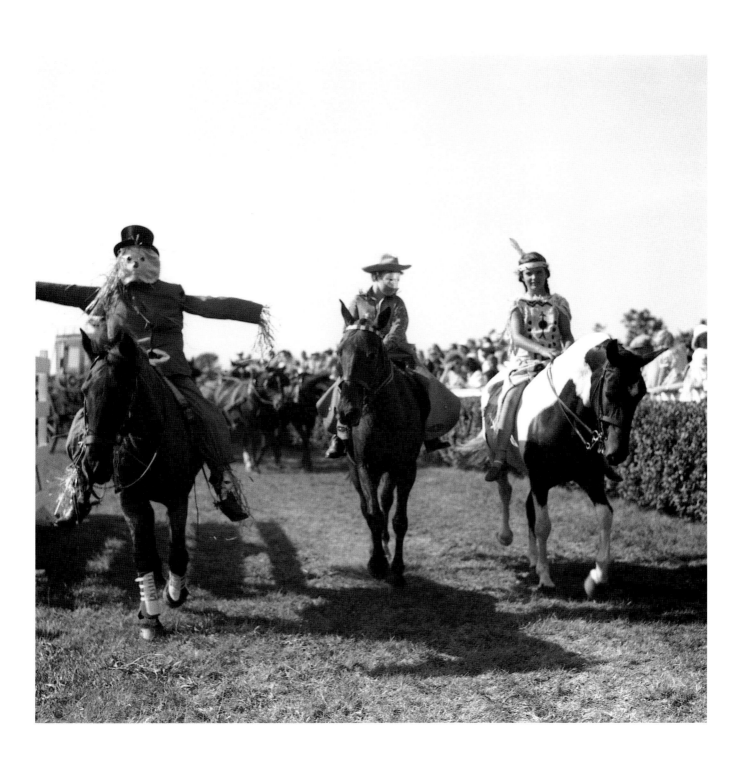

Jackie on Danseuse at the Smithtown Horse Show,
September 2, 1939.
OVERLEAF: *Jackie, riding Danseuse, takes the jumps at the Piping*
Rock Horse Show, Locust Valley, New York, September 30, 1939.

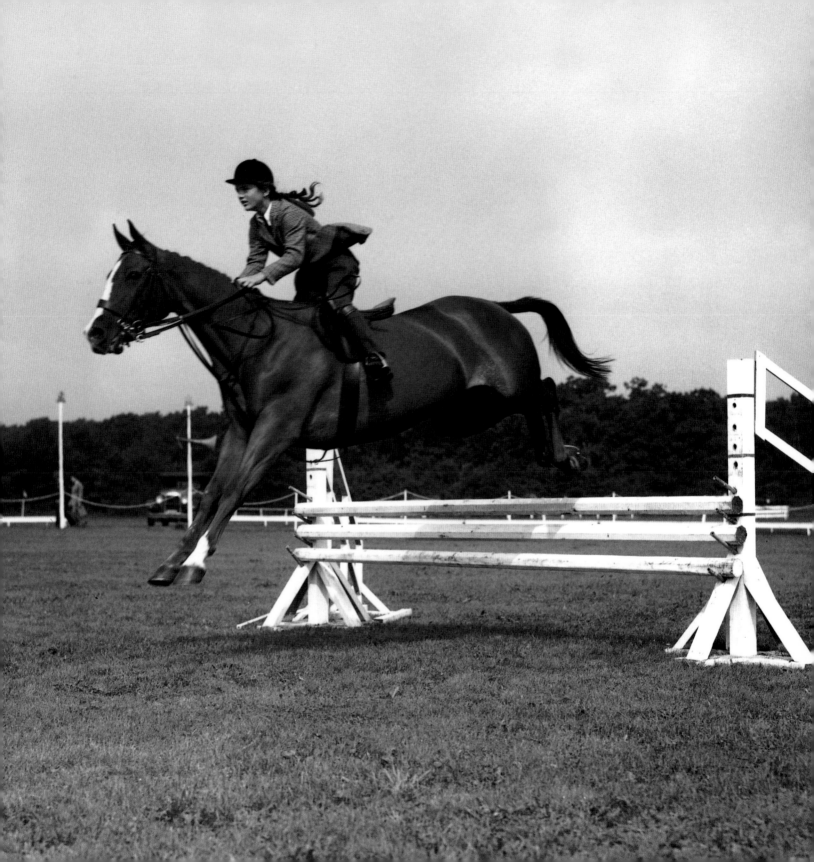

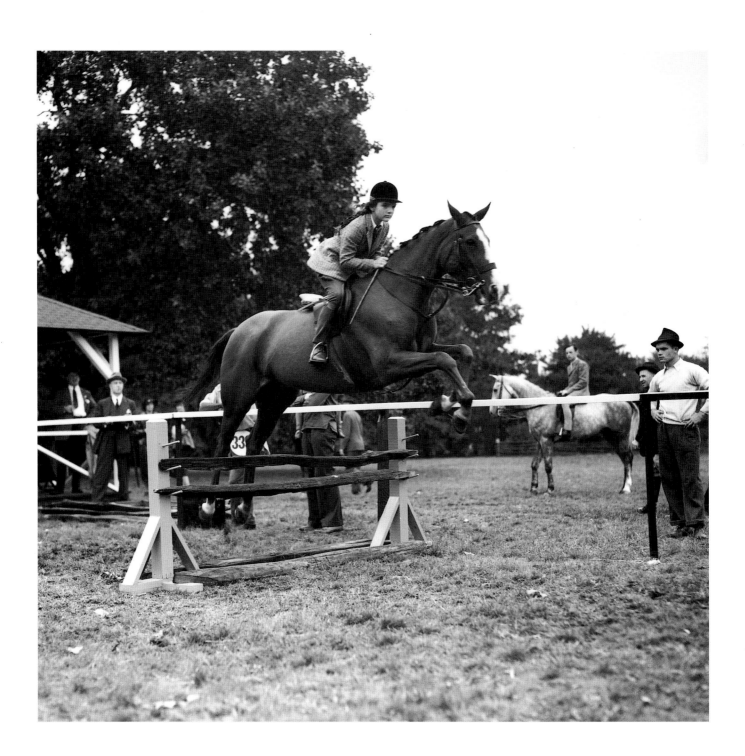

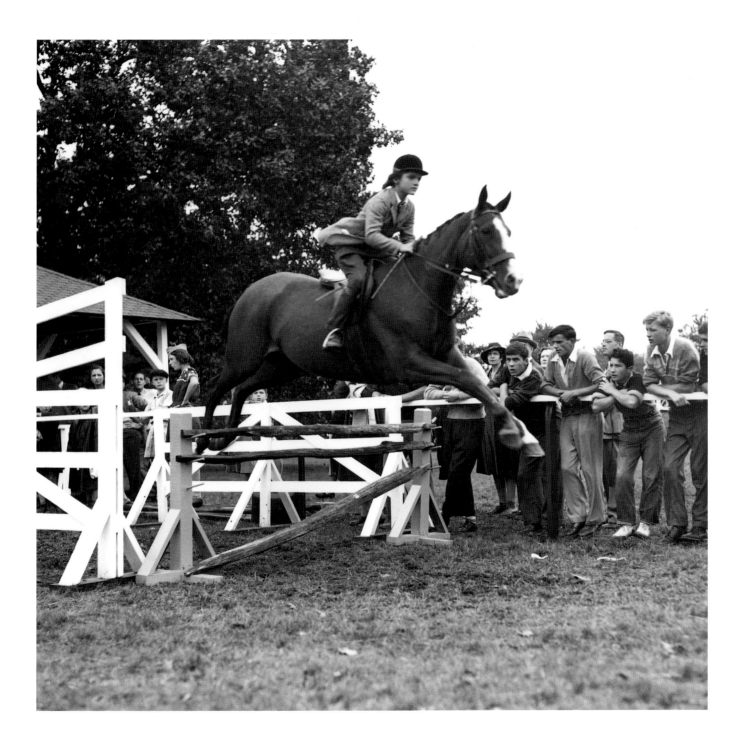

Mrs. John V. Bouvier III and her daughters Lee and Jacqueline
attending the Krech-Jackson wedding in East Hampton, July 26, 1941.
OVERLEAF: *Jackie, Lee and their mother Janet in line to*
greet the bride and groom at the Krech-Jackson wedding.

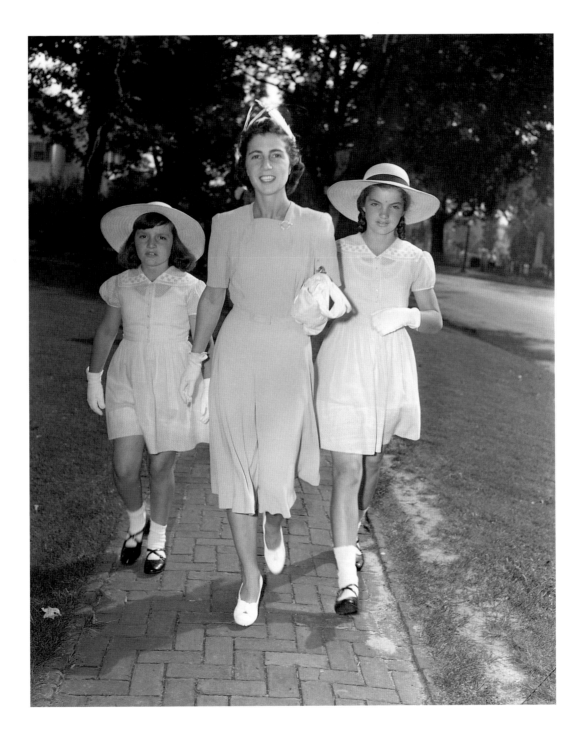

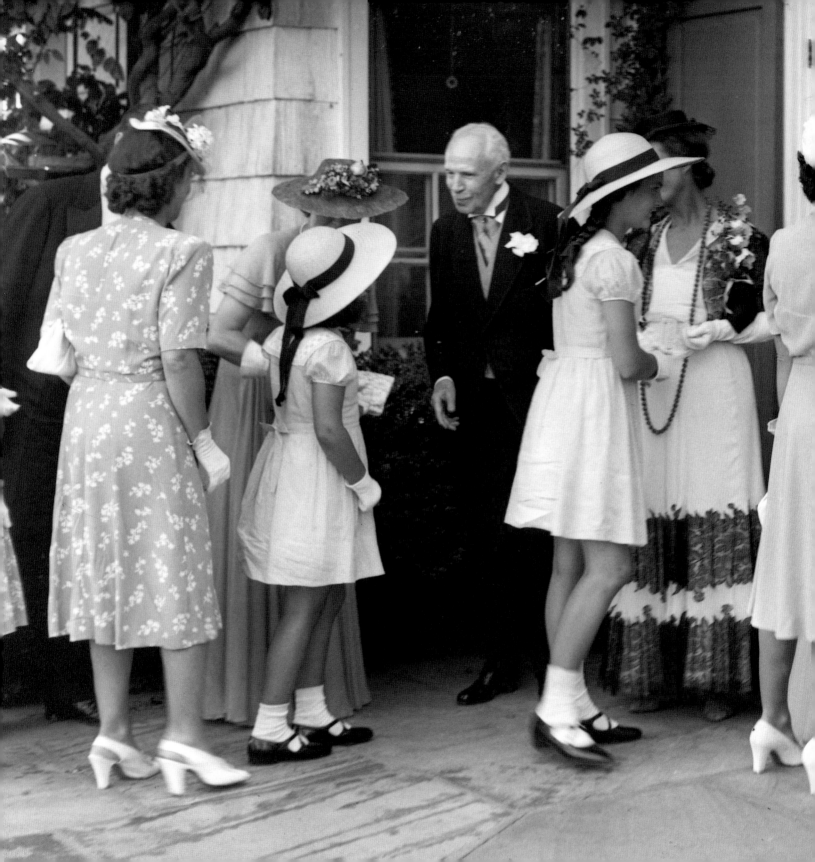

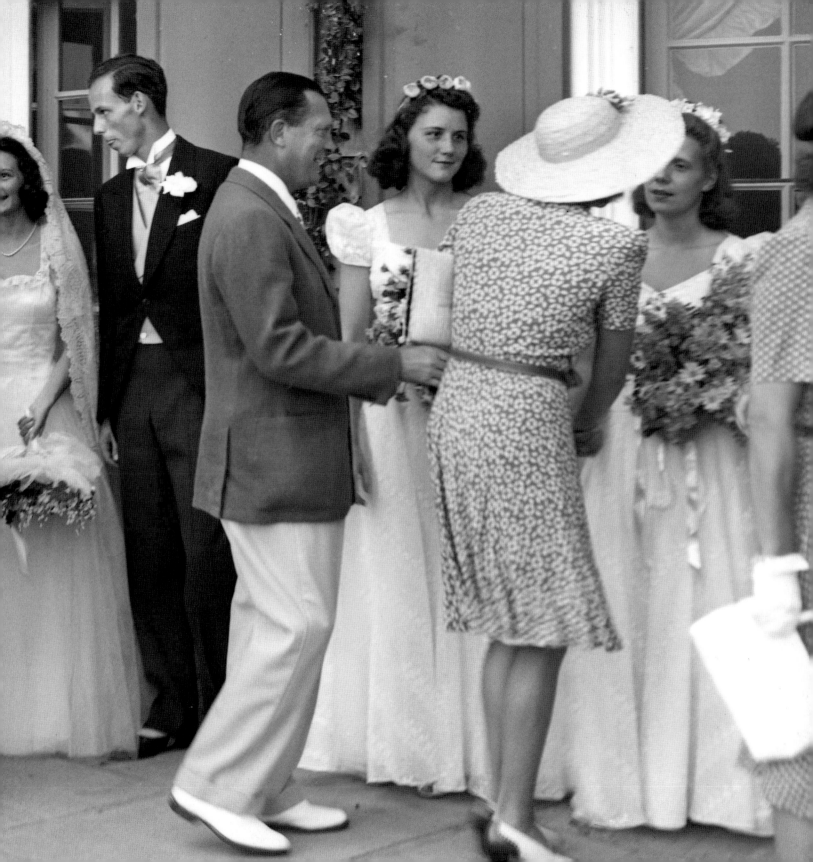

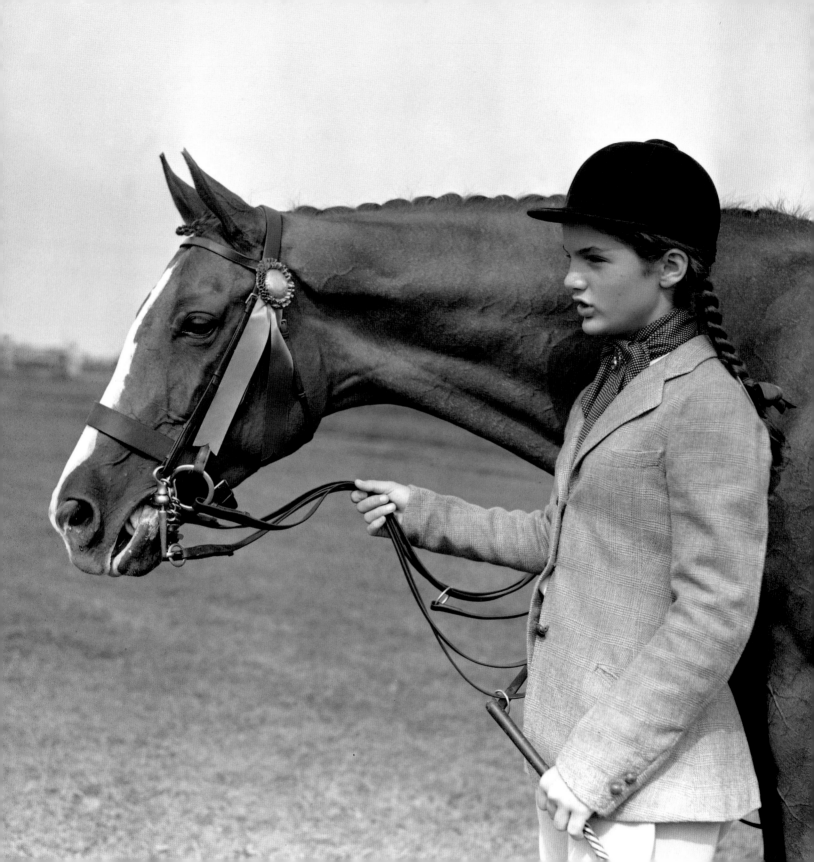

Jackie and Danseuse at the East Hampton
Horse Show, August 23, 1941.

Jackie and Danseuse take a jump at the
East Hampton Horse Show, August 23, 1941.

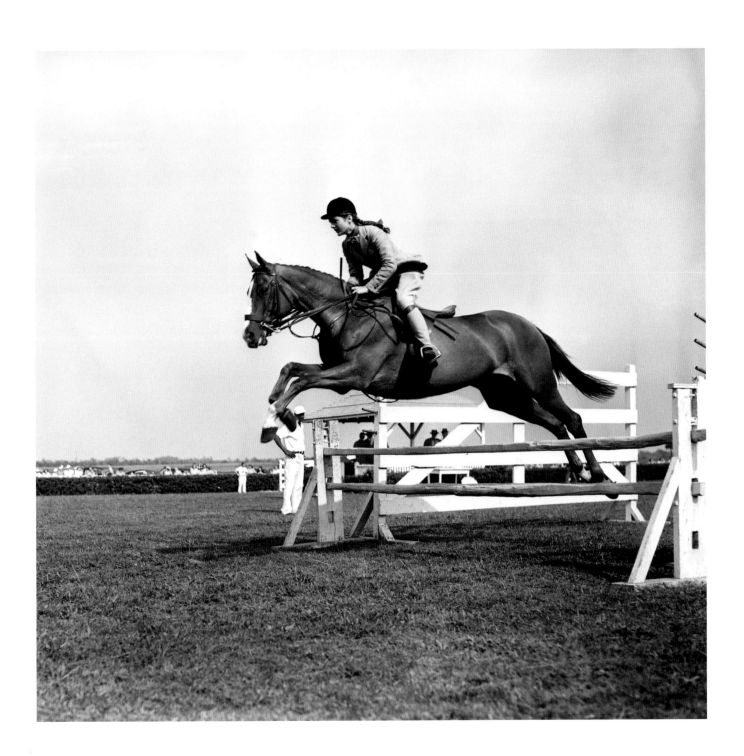

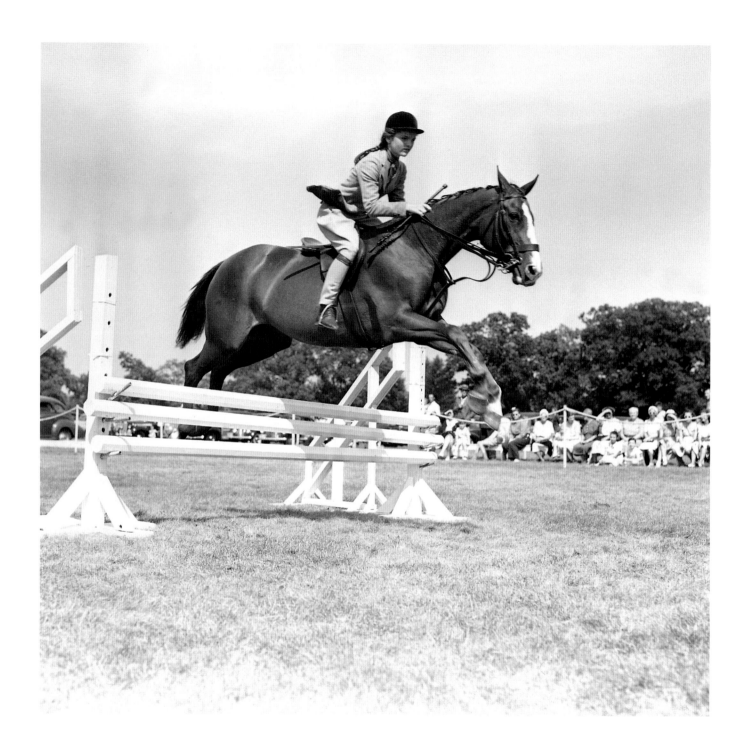

*Jackie and Danseuse a week later at the
Smithtown Horse Show, August 30, 1941.*

Jackie with Danseuse at the East Hampton Horse Show, August 23, 1941.

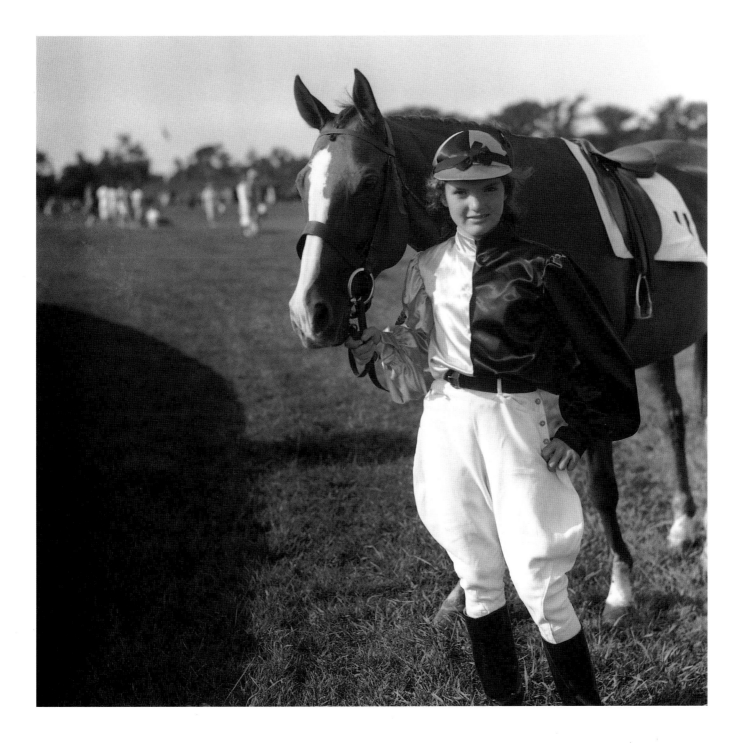

Jackie drives a carriage pulled by her piebald pony
Dance Step in the costume class event at the East
Hampton Tercentenary Celebration, August 15, 1942.

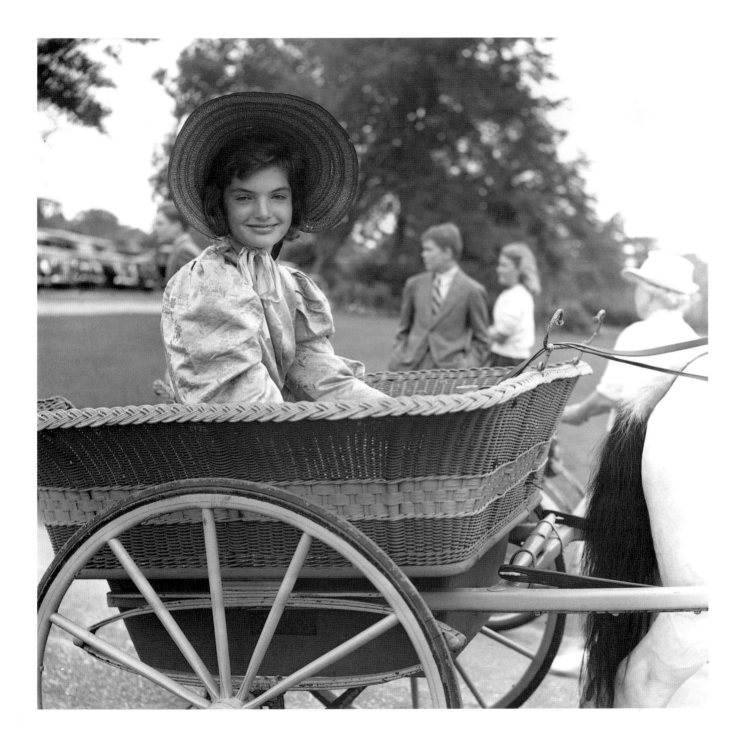

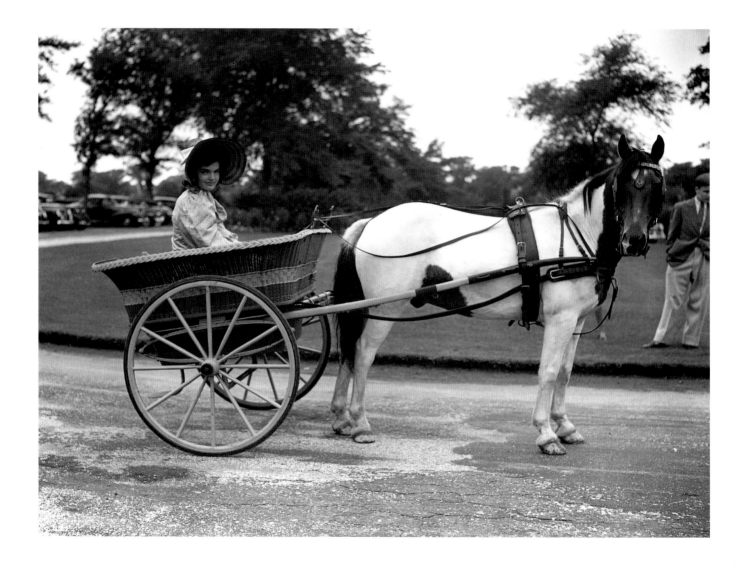

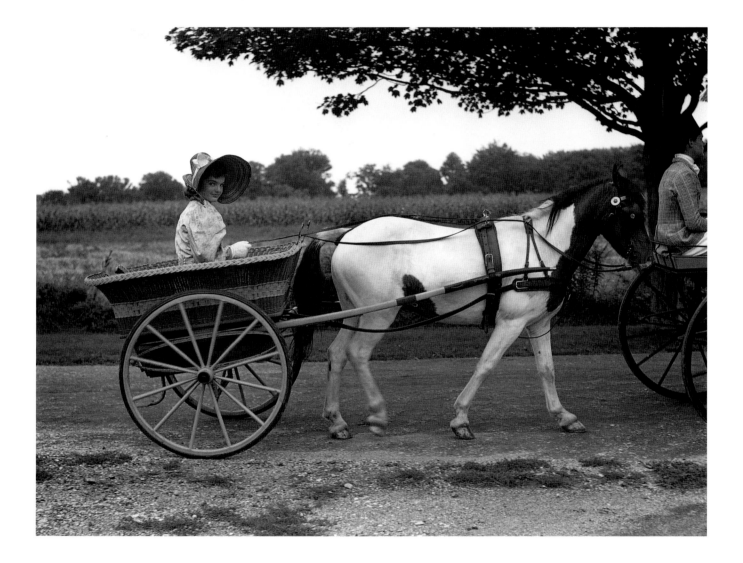

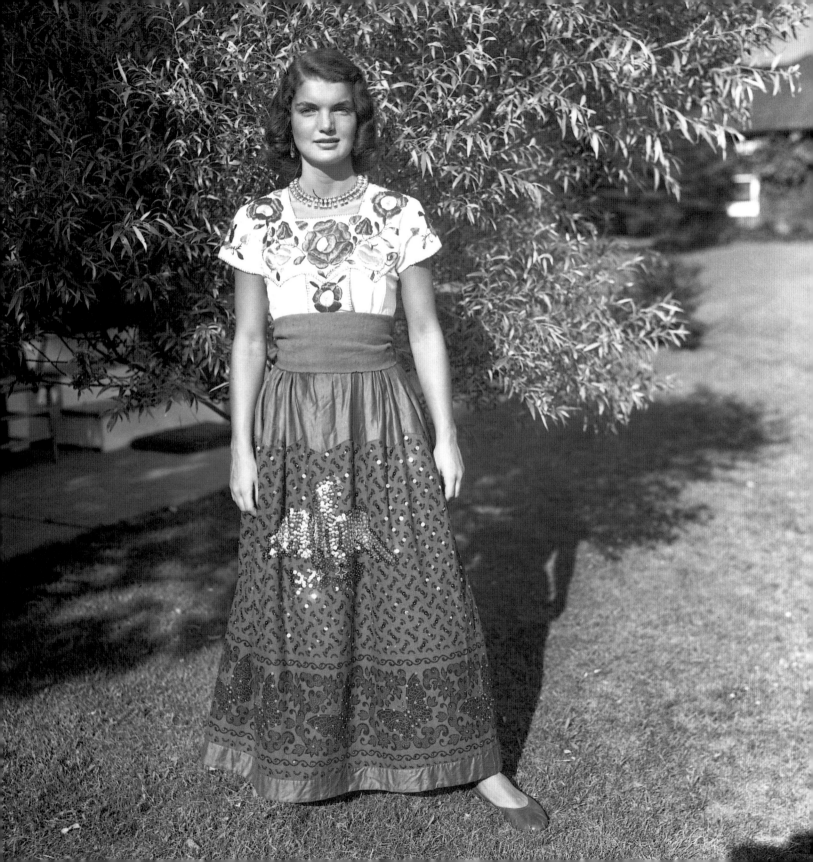

Jackie at an event in East Hampton, July 1949.
OVERLEAF: *Socialites Jacqueline Bouvier, Valerie Starke, Patricia Skidmore, Jean Washburn, Teloline Crabbe, Elizabeth Fly and Anne Robinson pose together in East Hampton, July 1949.*

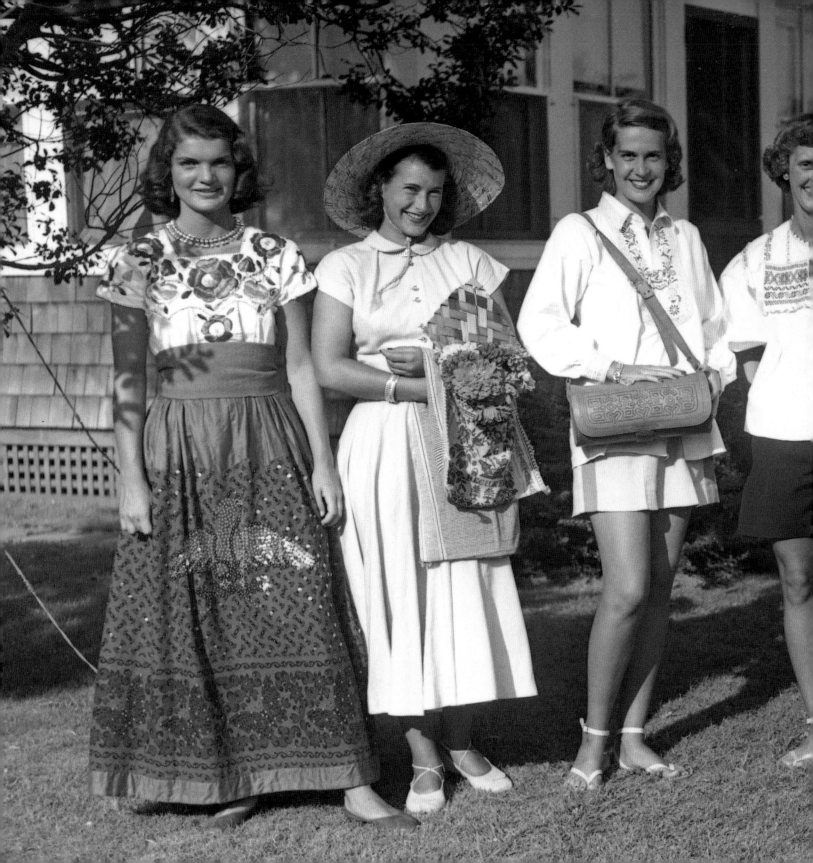

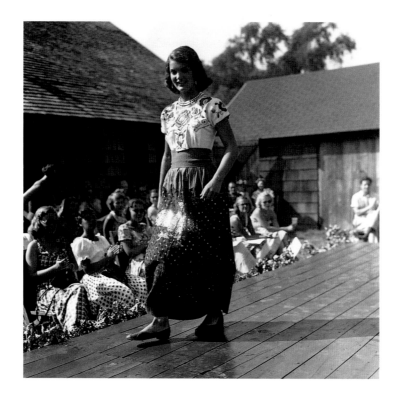

Jackie at an event in East Hampton, July 1949.
RIGHT: *Jackie poses with her father, July 1949.*

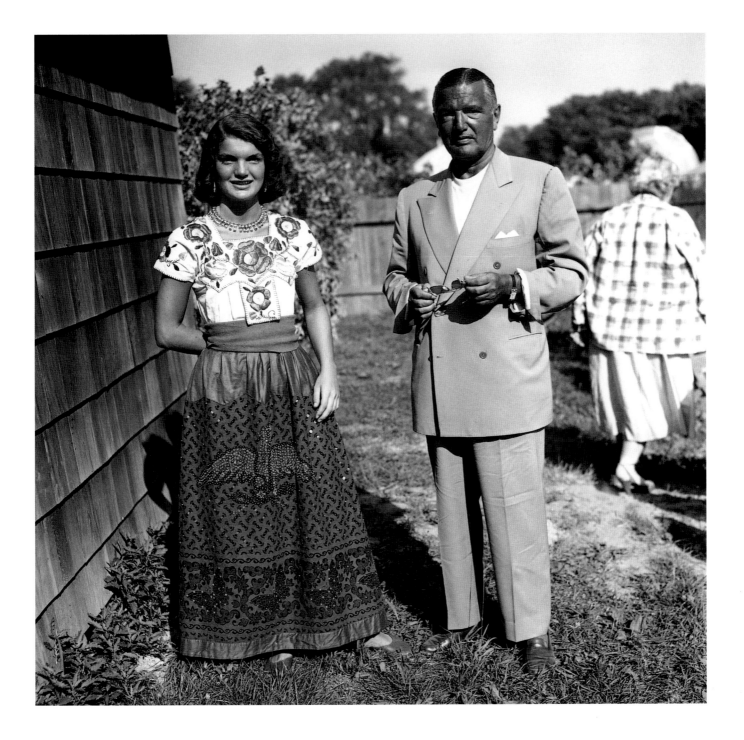

CHRONOLOGY

JULY 28, 1929. Jacqueline Lee Bouvier, daughter of John "Black Jack" Vernou Bouvier III and of Janet Norton Lee, is born six weeks late in Southampton Hospital, Long Island, New York.

OCTOBER 8, 1929. Black Jack's brother, William Sergeant "Bud" Bouvier, dies of alcohol poisoning, leaving his nine-year-old son Michel in Jack's care. Miche, as he is affectionately called, will grow to be Jackie's favorite cousin.

OCTOBER 16, 1929. Black Thursday. Although the Bouviers escaped ruin, the stock market crash will have a lifelong impact on the family's relationship to money.

DECEMBER 22, 1929. Jackie is christened in St. Ignatius Loyola Church on Park Avenue, in New York City. Miche is her godfather.

SUMMER 1929. Jackie's first visit to Lasata, her paternal grandparents' fourteen-acre property in East Hampton, where all the Bouvier households come for the summer. Jack, Janet and Jackie live in Wildmoore, the smaller East Hampton house in which Jack's parents lived from 1915 to 1925 before moving to Lasata.

JULY 28, 1931. Jackie's second birthday party at East Hampton cottage Rowdy Hall makes the social columns. Jackie shows her Scottie dog Hootchie at the annual dog show in East Hampton.

1932. Janet begins teaching three-year-old Jackie to ride.

MARCH 3, 1933. Birth of Jackie's sister, Caroline Lee Bouvier.

SUMMER 1933. Jack and Janet Bouvier throw a party for two hundred to celebrate their fifth anniversary, Jackie's fourth birthday and Lee's baptism.

SUMMER 1935. Jackie, age five, and her mother win third prize at the East Hampton family horse-riding competition.

SEPTEMBER 1935. Jackie begins schooling at Miss Chapin's School for Girls in New York. A straight-A student, Jackie is known both for her brightness and her mischief. She is often gently admonished by the headmistress, Miss Stringfellow, who understands the cause of Jackie's behavior and provides

her with support through her parents' quarrels. Jackie would later describe her as "the first great moral influence" in her life.

SEPTEMBER 1936. Janet demands a six-month trial separation from Black Jack, who moves into the Westbury Hotel. He sees his daughters on weekends.

SUMMER 1937. Janet and Jack take their children to Lasata together, before definitely splitting up at the end of the holidays. Jackie wins the Southampton Horse Show in the class for children under nine.

SUMMER 1938. Janet rents a house at Bellport, forty miles away from East Hampton. In August the girls join their father in Lasata. Jackie wins another blue ribbon at the East Hampton Horse Show.

AUTUMN 1938. Janet moves to 1 Gracie Square near Miss Chapin's School for Girls.

JANUARY 1940. Janet sues Black Jack for divorce on the grounds of adultery, informing the press of her charges. The *New York Daily Mirror* breaks the news of the Bouviers' separation and provides details of Jack's affairs.

APRIL 1940. Grandmother Bouvier dies.

JUNE 1940. Jack agrees to a Nevada divorce. Janet and the girls fly to Reno and take up residence at the Lazy "A" Bar Ranch, where Jackie spends most of her time riding.

AUGUST 1940. The girls leave Reno to join their father in East Hampton. Jackie wins every event in the undertwenty division of the East Hampton Horse Show, earns two top prizes at the so-called East End Horse Shows, and comes out first of twenty at the National Horse Show at Madison Square Garden. Grampy Jack distributes copies of his Bouvier family history, "Our Forebears," to the members of the clan. In it he invents an ancient noble ancestry dating back to 1086 for the Vernou side of the family and to 1609 for the Bouviers. The myth will be exposed only in 1967, when Jackie's cousin John H. Davis researches his family history.

EASTER WEEK 1941. Janet goes to Washington, D.C., with her daughters. Jackie and Lee are often left in the maid's care while Janet goes to meet her new beau, the immensely rich Hugh D. "Hughdie" Auchincloss II.

AUGUST 1941. Jackie wins the blue rosette in the hunter hacks class at yet another East Hampton Horse Show, as

well as the first prize for horsemanship for children under fourteen.

CHRISTMAS 1941. Janet takes Jackie and Lee to Washington to meet Hughdie and his son Yusha.

JUNE 21, 1942. Janet and Hugh D. Auchincloss II are married at his forty-six-acre Virginia estate, Merrywood. Jackie and Lee settle in their new home and join the Auchincloss clan: Yusha, who is two years older than Jackie, and Nina and Tommy from Hughdie's second marriage. Janet and Hughdie will have a daughter, Janet Jennings, born in 1945, and a son, James Lee "Jamie," born in 1947. Gore Vidal, Hughdie's stepson from his last wife's first marriage, will become close to Jackie when they meet five years later. Promptly after the wedding, the Auchinclosses go to Hammersmith Farm, Hughdie's seventy-eight-acre estate and summer residence in Newport, Rhode Island, where the Bouvier girls are put to work in the house, farm and gardens to replace the servants gone to fight the war.

AUGUST 1942. Black Jack rents a house in East Hampton for his daughters and for Anne Plugge, a married Englishwoman with whom he is having an affair.

SEPTEMBER 1942. Jackie leaves the Chapin School for the Holton Arms School in Georgetown.

AUGUST 1944. To Jack's delight, the girls return to East Hampton to spend the summer with him.

SEPTEMBER 1944. Jackie enrolls at Miss Porter's School in Farmington, Connecticut, where Hughdie's sister Annie Burr Lewis (Aunt Abie) lives with her husband (Uncle Lefty). Jackie rooms with Sue Norton in the first year and with her best friend from Chapin, Nancy "Tucky" Tuckerman, in the second and third years. She has Danseuse brought to the school, joins the drama club and contributes poems, articles and illustrations to the school newsletter for which she is also an editor in her senior year. Jackie studies hard, and especially enjoys art history and English literature.

1945–46. Black Jack moves into an apartment on the Upper East Side of New York City, where Jackie spends a few weekends.

FEBRUARY–MARCH 1947. Jackie

writes a short story entitled "Spring Fever" for the school newsletter.

JUNE 1947. Jackie graduates from Miss Porter's School, winning the Maria McKinney Memorial Award for Excellence in Literature. Janet organizes a tea party at Hammersmith Farm to celebrate both Jackie's debut in Newport society and the christening of Jackie's new half brother Jamie.

MID-JULY 1947. Traditional debutante ball at Newport's Clambake Club for Jackie and family friend Rose Grosvenor.

AUGUST 14, 1947. Grampy Jack's eighty-second birthday at Lasata. This is the last time Jackie sees her grandfather before his death in January of the following year.

SEPTEMBER 1947. While Lee goes to Farmington, Jackie enrolls at Vassar College to study literature. She also takes classes in studio art and art history and joins the riding club and the drama club and writes for the newspaper. She rooms with Edna Harrison, who occasionally goes to New York or to Merrywood with Jackie to spend weekends with Black Jack or the Auchincloss clan. Other friends include Puffin Gates and Shirley Oakes.

WINTER 1947–48. Debutante season begins. In January, Jackie is dubbed "Queen Debutante of the Year 1947" and becomes a media celebrity.

SUMMER 1948. Jackie goes on her first trip to Europe with three Vassar classmates and a former Latin teacher from Holton Arms as their chaperone. They go to London (where they shake hands with Winston Churchill and curtsy to King George VI and to Queen Elizabeth), Paris, Provence, the Riviera, Switzerland and Italy.

JULY 29, 1949. The Bouviers celebrate Jackie's twentieth birthday at Wildmoore rather than at Lasata. Jackie's twin aunts, Maude and Michelle, who inherited the property at the death of their father, have put it up for sale.

AUGUST 24, 1949. Jackie leaves for a year abroad in Paris on the Smith College course. She spends six weeks in Grenoble on a language course before enrolling at the Sorbonne in October. She and two friends from Smith College take up rooms in the home of a former Resistance militant, Countess Guyot de Renty, who lives in the Sixteenth Arrondissement.

WINTER 1949–50. Jackie goes to London to visit her father's former lover Anne Plugge, and meets the twins Anne gave birth to shortly after returning to England. Struck by their Bouvier traits, Jackie is convinced they are Black Jack's.

FEBRUARY 1950. Janet and Hughdie visit Jackie in Paris and take her to Austria and Germany. They go to Vienna, Salzberg and Munich and visit the Dachau concentration camp and Hitler's aerie at Berchtesgaden.

SPRING 1950. Jackie meets the young Comte Paul de Ganay, who introduces her to the French aristocratic scene. They go to Madrid and Toledo over the Easter holiday. Through a friend from Vassar and Newport, Jackie is brought into Louise de Vilmorin's artistic and intellectual circle.

JUNE 16, 1950. Jackie finishes her final exams at Vassar.

JULY 1950. Yusha comes to Paris. They go to St.-Jean-de-Luz with Countess de Renty's two daughters and return to Paris via Bordeaux. In August, Jackie and Yusha visit Ireland, Scotland and England.

SEPTEMBER 1950. Jackie returns to Merrywood after spending two days with her father in New York and enrolls at George Washington University for her senior year to major in French literature.

MAY 15, 1951. Jackie wins the *Vogue* Prix de Paris, for which she is awarded a one-year position as a junior editor for *Vogue* in both Paris and New York. Like the other 1,279 contestants, she had to send in a five-hundred-word essay on "People I Wish I Had Known" (Jackie chose Oscar Wilde, Baudelaire and Diaghilev), a plan for a whole issue of *Vogue,* a brief biography and four technical papers on fashion. However, Janet, who fears that Jackie will fall in love with Paris and become an expatriate, persuades her to decline the job. Meanwhile, she and Hughdie introduce Jackie to John G. W. Husted, a stockbroker and friend of the Auchincloss clan as well as of the Bouviers. Jackie goes to visit him in New York for weekend dates.

EARLY JUNE 1951. Jackie is presented to Jack Kennedy at a small dinner party in Georgetown hosted by her friends the Bartletts.

JUNE 7, 1951. Jackie and Lee set sail for Europe on the *Queen Elizabeth.* They go to London, Paris, Poitiers, Pamplona, Madrid,

Provence, the Riviera, Venice and finally Florence, where they meet the famous art historian Bernard Berenson, with whom Lee has been corresponding since she discovered art history at the age of fifteen. To thank Hughdie and Janet for their generosity, Jackie and Lee write "One Special Summer," an illustrated journal of their travels.

SEPTEMBER 15, 1951. Jackie and Lee return from Europe. Unsure of her plans, Jackie spends some time at Hammersmith Farm before returning to Merrywood.

DECEMBER 1951. Jackie is hired by the *Washington Times-Herald* as an inquiring photographer and is promptly promoted to the position of inquiring camera girl. John Husted proposes to her, and on January 21, the *New York Times* announces their engagement and forthcoming wedding in June. But by the spring Jackie has decided to return the engagement ring to Husted: she is not ready to give up her career for a man she is not truly in love with and wants to enjoy her freedom before settling down.

MAY 8, 1952. Jackie meets Jack Kennedy again at a dinner party hosted by the Bartletts and they begin seeing each other sporadically. Their relationship becomes increasingly serious, and by the fall there is talk of their engagement.

JANUARY 1953. John F. Kennedy takes his seat in the U.S. Senate and General Eisenhower is inaugurated as president. On January 20, Jack Kennedy escorts Jackie to Eisenhower's inaugural ball.

FEBRUARY 1953. Jackie introduces Jack Kennedy to her father.

APRIL 18, 1953. Lee Bouvier and Michael Canfield are married at Holy Trinity Church in Georgetown.

MAY 1953. Jackie is dispatched by the *Times-Herald* to cover the coronation of Queen Elizabeth II in London. On her return, Jack gives her a diamond and emerald engagement ring. The following day she resigns from the *Times-Herald*.

JUNE 24, 1953. Jacqueline Bouvier and John F. Kennedy are formally engaged to be married. The wedding date is set for September 12, in St. Mary's Church in Newport. Jackie begins preparation for what will be known as the Wedding of the Year.